EXPLORING

Calvin and Hobbes

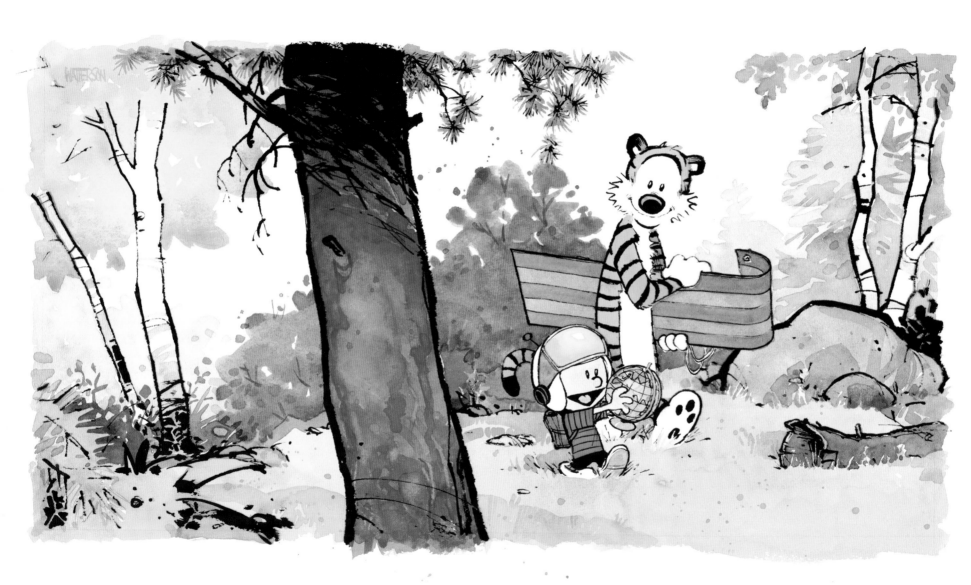

EXPLORING

Calvin and Hobbes

An Exhibition Catalogue

Bill Watterson

Andrews McMeel
Publishing®

Kansas City • Sydney • London

In cooperation with the Billy Ireland Cartoon Library & Museum
The Ohio State University Libraries

OTHER BOOKS BY BILL WATTERSON

Calvin and Hobbes

Something Under the Bed Is Drooling

Yukon Ho!

Weirdos from Another Planet!

Revenge of the Baby-Sat

Scientific Progress Goes "Boink"

Attack of the Deranged Mutant Killer Monster Snow Goons

The Days Are Just Packed

The Calvin and Hobbes Tenth Anniversary Book

There's Treasure Everywhere

It's a Magical World

The Complete Calvin and Hobbes

TREASURY COLLECTIONS

The Essential Calvin and Hobbes

The Lazy Sunday Book

The Authoritative Calvin and Hobbes

The Indispensable Calvin and Hobbes

CATALOGUE

Calvin and Hobbes Sunday Pages 1985–1995

CONTENTS

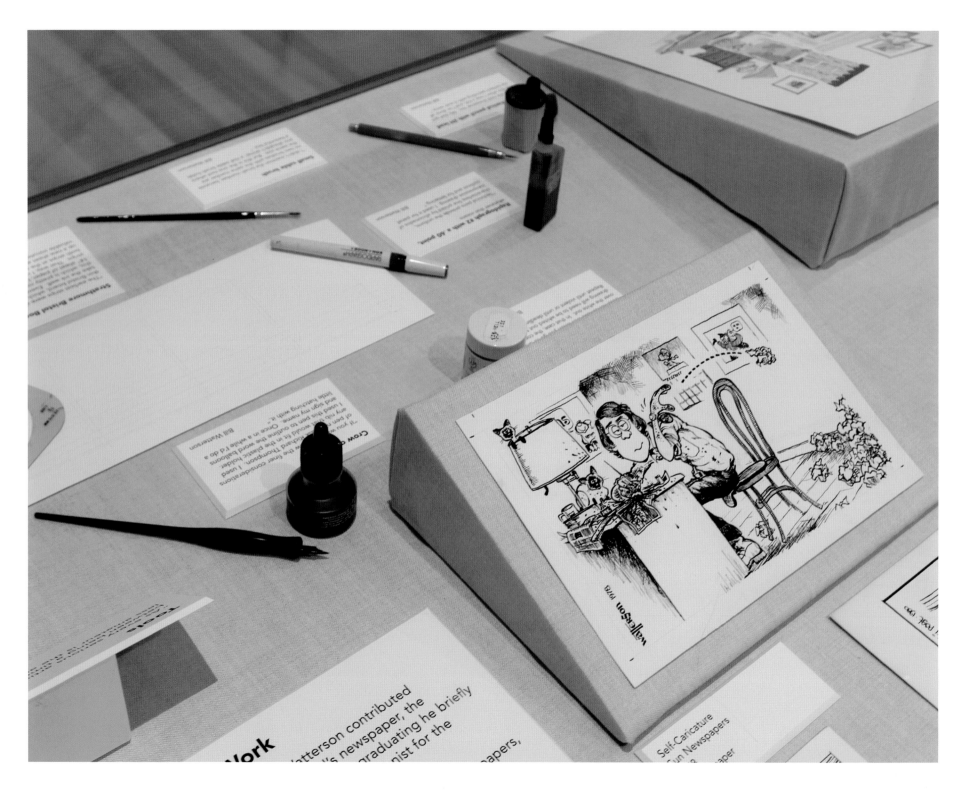

PREFACE

BILL WATTERSON'S *Calvin and Hobbes* had it all: humor, heart, and wisdom wrapped up in a beautiful package of sophisticated and lively graphic storytelling. From 1985 to 1995, the strip delighted millions of newspaper readers around the world. Even after Watterson ended the strip, new generations continued to discover it in book collections or online. *Exploring Calvin and Hobbes* encourages fans to revisit the strip in a new context and setting in the hopes that it will result in fresh insights into the wildly popular strip and its creator.

The Billy Ireland Cartoon Library & Museum is honored to house the Bill Watterson Collection of more than 3,000 original *Calvin and Hobbes* comic strips and related materials. Watterson placed the collection here in 2005, ten years after ending his acclaimed and much-beloved comic strip. The Library's mission is to preserve materials related to cartoons and comics, and to make them accessible to researchers and fans of the art form to study and appreciate. The Library contains more than 100,000 books, magazines, journals, and comic books; more than 300,000 original cartoons; and more than 2 million comic strip clippings and newspaper pages. In addition, it houses the archives of a wide variety of cartoonists, industry professionals, syndicates, and professional cartoonists' organizations. The Library's diverse and ever-growing holdings allow collections like Watterson's to be examined and understood in the context of the entire history of cartoon and comics art.

This is only the second solo exhibition of Watterson's work. The first, *Calvin and Hobbes Sunday Pages: 1985–1995*, was organized by Lucy Shelton Caswell and featured original Sunday strips chosen by Watterson. It was on display from September 10, 2001, to January 15, 2002, in the reading room of the Billy Ireland Cartoon Library & Museum, which was then called the Cartoon Research Library. The exhibition also traveled to the Cartoon Art Museum in San Francisco, where I was fortunate enough to be serving as curator at the time and where the exhibition was on display from February 16 to April 14, 2002.

In 2011, construction started on a new facility for the Billy Ireland Cartoon Library & Museum, with plans to include a museum with three exhibition galleries. The expanded facility provided the perfect opportunity to organize a larger and more comprehensive exhibition of Watterson's work. It also seemed like an ideal time to revisit and reexamine the strip and its place in the medium's history. When Caswell organized the first exhibition in 2001, Watterson didn't feel that enough time had passed to consider the exhibition a retrospective. Although we didn't

use the word "retrospective" in the title, this exhibition and the extended interview in this catalog are intended to serve as a retrospective exploration of the strip and Watterson's journey as an artist from his early efforts as a student until he ended *Calvin and Hobbes* in 1995.

The exhibition also gives viewers a rare opportunity to see Watterson's expressive brushstrokes and masterful watercolors in their original form. Examining his drawings and paintings reveals insights into his process that are not discernible while viewing reproductions of his work. Although the work was originally intended to be seen in printed form, there are wonderful subtleties—from his light pencils and occasional use of white-out to the variety of ways he approached coloring his art for book covers and illustrations—that are discoverable only through experiencing the original art.

For this exhibition, Watterson was interested in a more independent and objective review of his work, so he did not choose the specific strips to include. I was thrilled to make the selections, although it turned out to be a rather daunting task. In the first place, it's rare that we have such a complete collection of a cartoonist's work from which to choose. Second, the strip's quality was consistently high throughout its run. Both are very good situations to have when curating an exhibit, but they did make it difficult to whittle down the list to a manageable number that would fit in the gallery. My first pass resulted in more than twice as much work as we could show. It was painful to cut some of my personal favorites, but in the end, I hope the exhibition provides a representative selection that will appeal to a wide range of visitors, from the superfans who know every strip by heart, to those who are discovering the strip for the first time or rediscovering it after many years.

Watterson was actively involved in many other aspects of curating the exhibition and could not have been more generous with his time and ideas. Together we discussed the exhibition's themes, structure, and design. He chose the cartoonists included in the "Influences" section and wrote the labels describing the impact each had on his work. He also wrote descriptions of the tools he used to create *Calvin and Hobbes*. Finally, I am especially grateful to him for agreeing to sit down with me at the Library to discuss his life and career.

Exhibitions are always a team effort, and I had the good fortune to work with some wonderful people to make this one a reality. First and foremost, special thanks go to Lucy Shelton Caswell and Richard West, who were instrumental in initially bringing the collection to the Billy Ireland Cartoon Library & Museum and without whom this exhibition would not have been possible. The amazing staff of the Billy Ireland Cartoon Library & Museum including Susan Liberator, Caitlin McGurk, Wendy Pflug, Marilyn Scott, and Juli Slemmons all contributed their time and talents in important ways. I would also like to recognize the University Libraries exhibits team of Erin Fletcher, Justin Luna, Jeremy Stone, Harry Campbell, and Pam McClung for all their help with organizing, designing, and installing the exhibition. Steve Hamaker provided invaluable design assistance and was responsiable for the fantastic design decals in the exhibition. Many thanks go to the wonderful and patient people at Andrews McMeel Publishing, including Dorothy O'Brien and Joe Wormington. Finally, I am grateful to Carol Diedrichs, vice provost and director of University Libraries, and Lisa Carter, associate director for special collections and area studies, for their support of the Billy Ireland Cartoon Library & Museum and its distinctive collections.

Jenny E. Robb
Curator and associate professor
Billy Ireland Cartoon Library & Museum,
The Ohio State University

JENNY ROBB INTERVIEWS
BILL WATTERSON

Billy Ireland Cartoon Library & Museum, The Ohio State University
April 17, 2014

JR: *It's been a pleasure working with you on the exhibit* Exploring Calvin and Hobbes, *and I'm delighted to have this opportunity to sit down with you to ask you some questions about your life, your career, and comics. To get started, can you describe what it was like to grow up in northeast Ohio?*

BW: I grew up in Chagrin Falls, which is a small town, an outer suburb of Cleveland. It was originally a mill town in the 1800s, and a paper-bag factory was still going when I was growing up. They used to dump their dyes right in the river, so as a kid I remember seeing the river turn red and so on, if you can believe it. The town is fairly upscale now, but back then maybe a little less so. There was a hobby shop, a stationery store, three little drugstores, two hardware stores, and so on. Small local businesses where you could get pretty much anything you'd need without driving somewhere else. The Main Street bridge goes over a big natural waterfall, and Victorian buildings surround the town triangle, which has a bandstand in the middle of it. It's one of these quintessentially American towns that dot Ohio. Very Norman Rockwell—all white, very Republican. I had a sheltered childhood.

Our house was on a one-acre lot, at the outskirts of the village, with a big woods behind us. We didn't own the woods, but it extended all the way to the river, and you couldn't see an end to it. Our yard dropped continuously from the back door to the woods, so it was a truly fabulous sledding hill. There were a handful of neighbor kids about my age, so we messed around unsupervised in a way that kids don't seem to do anymore. Many of our mothers were home, so they'd just turn us loose and nobody worried.

Sometimes in the strip I tried to illustrate those big empty summer days spent messing around. It seems very anachronistic now that kids' lives are organized to the minute.

JR: *My husband and I are looking at houses, and whenever we see one with a woods, we call it a* Calvin and Hobbes *backyard.*

BW: To be honest, we didn't tramp around the woods all that much. Because it was low and heading toward the river, it was somewhat marshy and brambly. You'd get stuck full of prickers or tangled in brush, with your feet starting to sink into muck. We'd venture in occasionally, but it's not like I was Christopher Robin.

But I loved having that much nature around us. It mitigated the suburban feel, which I imagine is why my parents chose the property. Having something a bit wild and mysterious and beautiful at the end of the yard was a memorable thing.

Now it's a subdivision, of course. Looking at a cul-de-sac of McMansions doesn't have the same impact on the imagination. We like to think their basements are wet.

JR: *So what were you like as a child?*

BW: Everybody else was really weird, but I was completely normal. *(laughter)* I was generally a quiet kid. I lived in my head like Calvin, but I was the opposite of Calvin in terms of courting excitement and risk. It wasn't hard for me to meet the expectations of grown-ups, and I quickly figured out that if you did that, they left you alone and you could do what you wanted. So that was easy. It was negotiating the snake pit of schoolkids that I found difficult. My home and the slightly older kids in my neighborhood were a refuge.

I loved to draw, of course. When I was about Calvin's age, I was very interested in birds and dinosaurs, and I liked to draw them. I say I was interested in them, but I don't know that I actually read or learned anything about them. I just thought they were cool to look at, and I got so I could identify and draw all sorts of them. My interests were quite fanatical in their way—and at the same time, incredibly superficial!

JR: *Your parents were encouraging?*

BW: Yes, very encouraging, very supportive. My mom was basically my audience until I went to college, and my dad often introduced me to art supplies. He could draw pretty well, although he never had much time for it until later. When I was doing the strip, we'd go out and paint together on visits.

I think my dad was the one who told me *Pogo* was probably drawn with a brush. I tried copying *Pogo* characters—this was maybe in high school—but a brush line is hard to control at best, and because my brush was too large,—probably a watercolor brush,—I couldn't do it. It was very frustrating, so I went back to pen, and it wasn't until college that I gradually figured out you can get tiny brushes that will make a thin line, and I worked on developing the necessary touch. There was never any information back then, but I always had materials to play with.

Really, I suppose the biggest gift my parents gave me was a lot of time. There was never a sense that I should be doing something else. If I was up in my room drawing, nobody bothered me. That kind of time is just indispensable. It's not a luxury, it's an absolute requirement. You've got to mess around—it's the only way to figure stuff out.

It's hard to reconstruct this accurately, though. My memory is that I spent hours and hours drawing, but it may have been fifteen or twenty minutes, who knows. A kid's idea of a long time is not reliable information. But I drew comics from a very early age. It was the only kind of art I understood, and it connected immediately. The simplicity of the drawings was like a big welcome mat. My whole childhood was about cartoons. I just loved them.

JR: *To elaborate a bit, how exactly did you learn to draw cartoons? You mentioned copying* Pogo. *Did you ever have any classes or formal art training? Or training in cartooning?*

BW: No. There *were* no classes in cartooning then. Cartooning was what you did to *avoid* classes! And it's funny: although I'm certainly glad cartoons are finally getting some respect as an art, I'm fairly ambivalent to see cartooning as a legitimate academic offering. If comics need to be deconstructed and explained, something is really wrong with them.

I found a *Pogo* book in fifth grade, at a library book sale. I picked it up, thinking my dad might like it, but I ended up keeping it. My parents had liked *Peanuts* and *Pogo* around their college years in the mid-'50s. Those strips were a little bit edgy for the time, more intellectual, new and different. I think the first *Peanuts* books I read were just lying around in the house. But for years afterward, I asked for *Peanuts* books for Christmas and birthday presents, and I eventually amassed all the old Holt Rinehart books. Each book was a dollar, and I remember the agony of deciding which one to buy with my own money.

I had that *Pogo* book for a while before I read it. The cartoons were so dense and black, with a thousand words in every strip. It was a visually oppressive thing to look at when you've grown up on *Peanuts*. And I think the newspaper comics pages had already pretty much changed by this point. There were still some continuity strips hanging in there that had a lot of black, but most of the gag strips that I liked had followed the *Peanuts* path toward simplicity and white space, especially as the comics began shrinking. So it took me a couple of years before I sat down to seriously read *Pogo*, and I don't know what I made of it at first, but the lovely drawings pulled me along until I grew to love the whole strip. All this was late middle school.

Peanuts was there from the beginning, though. I had no idea what a weird, strange strip *Peanuts* was. Being a kid, I just took it at face value. The expressiveness of Charlie Brown's misery connected, but it was Snoopy and the more fantastic, silly stuff, that really grabbed me.

JR: *The Red Baron strips?*

BW: Right, the Red Baron strips, definitely. Those drawings are just lovely. Snoopy wearing goggles, sitting on his doghouse, gritting huge teeth—the premise and the execution are both insane. I admired them to no end. I still do.

There was a great serendipity with *Peanuts.* The strip became this pop culture tsunami just at the time I got into it. The licensing was just ramping up and *Peanuts* was everywhere. I loved getting each new book, and I was thrilled when the Christmas and Halloween TV specials came out. It all happened right when I was most receptive to it. *Peanuts* was one big, long cartooning class for me— even the writing, which I wasn't aware I was absorbing. The length and pace of a story, how to create suspense—I soaked up all those things just from reading it so much. And over time, the machinery of comic strips became second nature as I started drawing my own comics.

My earliest comics were not very involved. I'd just fold a sheet of notebook paper into eight squares and try to get something that passed for a punchline at the end.

In middle school, I started drawing with a cartridge pen. My sixth-grade teacher—rightly, but rather peculiarly—hated ballpoint pens, and she made us write all our papers with a cartridge pen, with real ink. I'm sure we were the only twenty-eight kids in America using real ink pens at that time, but I thought they were absolutely great. It's a beautiful, flowing way to write. So I started using that for cartoons, and I often drew my cartoons in blue. I never penciled anything—who's got that kind of time? I just drew with the pen. By then, I was coming up with some little characters and trying to write jokes and situations for them. I'd bang one out and see if I could get my brother or my mom to laugh.

JR: *Did you read any comic books growing up?*

BW: Some, but nothing made a big impression. I read some Batman comic books when the '60s Batman TV show came out. It was good cheesy fun, but just sort of a diversion, nothing I cared much about.

A little later, through much of my teens, *Mad Magazine* was a big deal for me. I liked Don Martin, Sergio

Aragones, Mort Drucker, and some of the others, although today I don't look back on the magazine with any real affection. You know, it's great when you're eleven. But if it had been a better magazine, a little deeper, you could reread it at age fifteen or twenty and get more out of it. But you can't—it's just humor for eleven-year-olds. And they're willing to lose their audience at age fifteen, because there's a new crop of eleven-year-olds every year. They don't need to reach any higher, and that just seems lazy to me. *Mad*'s irreverence seemed revolutionary at the time, but now I think it was mostly cynical—a snotty-kid attitude—not really based on any moral outrage. They ridiculed things not because they truly objected to them, but because those things were popular, and they wanted to ride that wave. So this magazine that I thought was wild and rebellious at age eleven now just seems sort of easy and dumb.

We should probably edit that out. *(laughter)*

JR: *Growing up,* Mad *didn't resonate with me the way it did with some of my peers, but I don't think I was their primary audience. Not that it was entirely a gender thing, but I knew more guys who read it.*

BW: Right, I think it was sort of a boys' club. There are plenty of cartoonists who get dewy-eyed thinking about *Mad* all these years later, but I'm not one of them. There was a period in the '50s when it was energetic, but by the time I was reading it in the mid-'60s, it was very formulaic. Even as a kid, I was puzzled by the fact that, after a movie satire by Mort Drucker, they'd have a TV satire by a Mort Drucker imitator. They turned Drucker into a house style for caricature! That sort of thing galls me now, but even as a kid, it seemed odd and vaguely disappointing.

JR: *Was your family religious at all, growing up?*

BW: No. To be honest, I'm glad I got to figure out what I think about those issues on my own, without having to fight somebody else's dogma to get there. So I was happy enough to avoid churches, but when I got to college, I had occasion to discover what a hole that left in my education. I took a general art history class, and of course, so much of art was religious painting, and I was just lost. I didn't know the Bible stories, who the people were, what they meant, or anything. I didn't get a lot out of certain classes.

So, on the assumption that you're leading up to why I named my central character after a sixteenth-century theologian . . . well, it was a joke. *(laughter)* Mostly on me.

JR: *What did you study in college, and how do you think your studies might have informed* Calvin and Hobbes?

BW: I went to Kenyon College, which is a small liberal arts school in central Ohio. Very pretty campus on a hill overlooking cornfields. It's known for the *Kenyon Review*, not that I've ever read it. English had been one of my favorite classes in high school, so I thought that might be what I'd study. I took a lot of English classes at Kenyon, but much of the reading made my eyes glaze over, and for rather misguided reasons, I ended up majoring in political science.

The importance of Kenyon to my cartooning was more personal than academic, because within days of arriving, I saw that the school paper had been printing these astonishingly professional-looking political cartoons by Jim Borgman, who, very conveniently for me, had just graduated. Borgman had been hired by his hometown paper, the

Cincinnati Enquirer, immediately upon graduation, and the fact that he had somehow cracked the code to becoming a professional cartoonist was incredible to me.

When I was in high school, I had drawn a handful of political cartoons for the local suburban paper. My town had gotten some new police cars that were very fancy, so my mom talked me into submitting a drawing of a souped-up police car with all sorts of bells, whistles, and foghorns on top. To my great surprise, the paper not only printed it, but they enlarged it, so it was gigantic on the editorial page. Being seventeen or whatever, this made my *head* pretty gigantic too. I occasionally submitted some other cartoons, and gradually this became a sort of freelance summer job.

So anyway, I get to Kenyon and see that Borgman had great success doing political cartoons, so I decided to continue in that direction and do political cartoons myself. I'm sure that if I had presented the paper with a strip or single-panel cartoon, that would've been absolutely fine, so this line of thinking was a bit screwy on my part, but it seemed Jim had paved a big wide road that evidently led to prestigious employment, so I figured I'd put my car on that road.

Seeing my interest, someone on the school paper told me, "You need to talk to Rich West." Rich was a junior that year, and had been a friend of Borgman's, so I introduced myself and we hit it off. Rich had a deep interest in history and early American political cartoons, and I don't think he could believe his luck to come across *two* serious cartoonists at this out-of-the-way college, so he encouraged me endlessly. In short, the minute I set foot on campus, I made two personal connections that were extremely formative for my cartooning career.

And then, with political cartooning in mind, I started steering my academic work toward this goal, because I literally knew *nothing*. It would be hard to exaggerate how backward and ill-informed I was.

JR: *You mean about politics…*

BW: About *everything*, but especially politics! I guess it's a testament to the power of self-absorption, but all the conflict of the '60s might as well have happened on Neptune as far as I was concerned. I was a bit younger than the Woodstock generation, and not having a personal stake in the social upheaval, I had the luxury of being pretty oblivious. Vietnam and Watergate were over by the time I got to college.

I learned a little bit over the years at college, but needless to say, political cartoons were always terrifically difficult for me, since the subject matter was not any sort of genuine passion. Looking back, I can see it was the totally wrong direction for me all along, but at the time, who knew? Maybe I could figure it out with a little more work. I was dogged—that's all that got me through. If a cartoon got drawn, it was through sheer force of will. I didn't have any knowledge, I didn't have any strong beliefs or opinions . . . the only part I actually cared about was the cartooning. All the rest was just what I had to do to get to the cartooning part. It was nuts, but that's what I did for four years.

JR: *Were you paying attention to specific political cartoonists at the time?*

BW: Yes, and that was fun. Previously, my pool of influences was pretty small—mostly the few comic strips I liked.

Pat Oliphant's work became very important to me, although I'd actually known of his work even as a kid. Jeff MacNelly was a big deal in the Carter years, when I was in college. MacNelly had a lighter, more jokey take on events, with wonderful, elaborate drawings of trains and machinery and things. I think Oliphant holds up a lot better—more venom and variety in his work—but MacNelly's artwork influenced virtually everybody working then. I got Mike Peters's early books of political cartoons, and those were fun. Again, a pretty silly sense of humor, and there was a craziness to the drawing that was a thrill. His wildly exaggerated caricatures were a big surprise. And Borgman, of course. He'd mail me batches of his work with a letter periodically, and that was such a boost and inspiration. I marveled at his visual inventiveness.

Editorial cartoons typically had more space to work with than comics, and a lot more visual complexity than I was used to, and it was a bit scary to discover the limits of my drawing skills when I tried to do a more involved picture. I couldn't draw nearly as well as I thought I could.

At the very beginning of freshman year, the art department had an orientation meeting, where they explained how the program worked. Everyone was required to take an intro drawing class, and after the meeting I went up to the drawing teacher, Martin Garhart, and asked if I really had to start at the beginning, since I was pretty hot stuff with a pencil and could be moving along if they'd get out of my way. *(laughter)* He gave me this cold look and said, "I think I can teach you something." So I took Drawing 101, and man, he taught me a *lot*! *(laughter)* Yeah, it was sad. My skills were pretty thin.

JR: *You liked the class?*

BW: It was quite challenging. Garhart taught Borgman too. A great teacher, very interested in narrative art. He was a printmaker at that time, but he's since gone into painting. Yeah, he knocked my head into the wall.

JR: *Did you take other art classes beyond that?*

BW: I allowed myself one full credit of art every year. I look back at Kenyon as an ocean of missed opportunities and misdirected efforts. I should've gone to college when I was thirty-five. My parents never tried to steer me at all, but I would've felt irresponsible taking a lot of art when they were paying that much money for my education. I figured I could learn art on my own, and might prefer to anyway. But over the years I took classes in drawing, life drawing, and printmaking. I had some very good teachers and got a lot out of them all.

I never took any painting. I knew they'd be teaching us about color, and the idea of sitting there mixing colors seemed soooo tedious. So I skipped that, and had to figure it all out the hard way twenty years later. For senior year, I took a self-directed, make-whatever-kind-of-work-you-want class. I didn't have enough inner resources to know what to do with that, so I sort of coasted through and never pulled it together. It was wasted on me. Fortunately, I wasn't an art major.

It's funny—I'm sure the teachers would have been receptive if I'd done cartoons as a senior project, but I never wanted to mix cartooning with art classes. I guess I wanted to keep cartooning separate and all my own. That may have been a bit pigheaded on my part, but I wanted to make my

own mistakes and figure out my own solutions in my own way. I'm pretty much the same way with painting today—I've never taken painting classes. I guess at some point, the things you need to learn are things nobody else can teach you.

JR: *After college you worked briefly as an editorial cartoonist for the* Cincinnati Post, *but the job was not a good fit. Why do you think you were more suited to drawing a comic strip than political cartoons?*

BW: Again, I was fairly self-deluded about doing political cartoons. I thought I could muscle my way through it. I figured that time and effort would make it happen. But after the *Post*, when I finally went back to comics, it was like coming home. Comic strips were sort of the language I grew up speaking. I think I took that fluency for granted and figured I could leverage it into other fluencies. But political cartooning just wasn't the right outlet for my personality and interests.

The *Cincinnati Post* was a disaster from all directions. It was my first job and I was young and very naive. I'd never lived in a city and I had no business being on a newspaper of any real size. I didn't know what I was doing, and that was scary.

I was hired on a six-month trial basis. Halfway through, the editor told me I could leave then or stick out the agreed-upon time, but this wasn't going to work. I had nowhere to go, so I stuck out the full term for the sake of paying my rent, but continuing to work after being fired just added another layer of lunacy to an already surreal situation.

I'd worked *for* newspapers a lot, but never *at* a newspaper. I was used to drawing cartoons alone in my room. Ninety percent of what a cartoonist does is stare into space, so it's not something I generally care to do with an audience. All of a sudden I'm in the middle of a newsroom with a hundred other people, and it's chaos. They gave me a table by a blaring police scanner. It was pandemonium all around me as I sat at my desk, open-mouthed and blinking.

I had to take my roughs to the editorial page editor for approval. She rarely okayed anything, but if she thought my sketch was potentially acceptable, she'd send it over to the main editor, whereupon he'd pass it back saying it was no good. So I'd come up with another idea, and *he* might like it and *she* might not, so he'd reevaluate and decide she was right—it was no good. So I'd come up with another idea and *neither* of them would like it. In this manner, I might get one cartoon published in a week of sitting there banging out roughs, and I felt like a total fraud.

All the more so because the pay was pretty nice. I was actually on the editorial staff. In 1980, George Bush Sr. was on the ticket with Reagan, and suddenly the word went through the newsroom that Bush was coming up to talk to the editors. Being in the editorial department, I was invited. So I'm twenty-one, an impostor at my job, sitting in the editor's office with all these middle-aged editors and seasoned reporters, and I'm doodling pictures of George Bush while he's sitting a few feet away. You know, absolutely every aspect of this scene was just plain wrong. So when I got fired, I was crushed and mortified—but there was no sense of injustice! *(laughter)*

I sent out submissions to other papers for another year, but couldn't get a bite. Having nothing to lose, I went back to comic strips and there was an almost palpable sense of relief. You don't need to know anything—you just make stuff up!

JR: *Well, it's a great example of failure turning into spectacular success, but it's hard sometimes to see that while you're involved in the failure.*

BW: True, although there were a number of years out in the wilderness.

My failure was probably one of the best things that ever happened to me, although I don't recommend the humiliation and insolvency so much. But if my experience at the *Post* hadn't been so catastrophic, I don't think I would have started over. I'd have limped along doing weak editorial cartoons, and would never have gotten to what I was good at. I didn't want to throw away all that time and effort, but sometimes you can't move forward without going back to the beginning to get your bearings again.

And in the long run, nothing is wasted. It takes a while to see this, but it's true. I learned a lot about drawing and about how to work with complex ideas from those years. It was valuable.

The failure also raised the stakes for me on a personal level. Years later, when I finally got syndicated—when they finally opened the gate—I ran like my head was on fire. The *Post* failure made me realize that this wasn't going to come as easily as I'd thought. So I treated the marathon as if it were a flat-out sprint.

JR: *After the* Cincinnati Post, *you returned to the Cleveland area and were working for a shopper newspaper, doing car and grocery ad layouts. You were also creating a number of different comic strips and sending them off to the syndicates. What were some of the early ideas or devices that eventually found their way into* Calvin and Hobbes?

BW: I wouldn't look too hard for connecting threads in my early submissions. These were random shots into the dark.

My comics submissions were not deeply thought out. I always hoped for the best, of course, but I didn't really expect them to become syndicated, or at least not as-is. I had no idea how the system worked. I didn't know how syndicates operated or what they looked for, or how you were supposed to go about this. If there was any published information on this stuff back then, I never saw it. So basically, I was trying to show that I could write and draw, hoping maybe I could just wedge my foot in the door and get a response. If an editor had said, "We're looking for a strip about monkeys," I'd have been happy to try it. But generally, all I got was a form-letter "no thanks."

As each strip idea was rejected, instead of going back and revising it, I would try an entirely different tack. You don't like spacemen? Here's college kids! You don't like college kids? Here's animals! I was not coming at this with a coherent vision or sense of personal mission. I was just trying stuff, throwing things out there to see what might work. There might be a flicker of potential here or there, but these were not strong submissions by any standard. Occasionally I'd get a letter back from an editor saying something like, "Your work is more interesting than much of what we see." But nothing concretely helpful.

That was frustrating at the time, but actually, it was a good thing they didn't offer advice. You don't want a syndicate telling you what to draw—there will be no spark unless it comes from your own ideas. What I didn't realize was that nobody out there knows what they're looking for until they see it. You don't build the peg to fit a hole; the peg needs to bore its own hole.

So anyway, I just experimented. My submissions had flimsy foundations, so they'd start wobbling fifteen jokes in, but that's how I learned. Simple trial and error. I had nothing to lose.

What I'm trying to emphasize is that my progress was not linear. I bounced all over the place. Each new strip was not necessarily a step forward from the previous one. Some *aspect* might be better, but several other aspects might be worse. And the thing that worked in *this* strip might not work in *that* strip. A comic strip has a zillion moving parts that all have to function together. It's tricky to make a strip that flies. You go through a lot of parachutes.

And in light of how my strip ended up, it might be surprising that I never tried submitting a kid strip, but I felt Schulz had taken all the oxygen in that room. I also probably thought that doing a kid strip would be too ordinary, safe, and bland. But when Sarah Gillespie, an editor at United Features, suggested I focus on this little side character I had, the boy who turned out to be Calvin, all of a sudden things started to click. I was aware of it immediately, because he was fun to write. He had a voice.

JR: *That was actually one of my questions. You could tell right away?*

BW: Pretty much. That's not to say it was a smooth ride, but for once some of the wheels were turning. And I think working with a small child as a character gave me two advantages. One, I had *been* a small child, so I was finally describing my own world. And the second

thing is that a child character gives you a certain comedic distance when you're writing.

Animal characters are probably the most fun to work with because they can be anything you want, but the second best thing is a little kid—and as it turned out, I put the two together. There's a lack of literalness when you work with those kinds of characters that I found very freeing. I once said about *Bloom County*'s Opus that when you draw a penguin sitting on the toilet reading the newspaper, it's funny, but if you put an adult man there, it's disgusting. With more fanciful characters, you're freed from the expectations and baggage of realism, and you have more latitude. Everybody knows you're playing around. Readers just naturally cut kids and animals more slack. So all that helped create a more winning world from the get-go.

But the most important thing was that the character had a voice. From the very beginning, unpredictable things seemed to come out of his mouth, and he surprised me. When you get that, you grab on tight. That voice is exactly what you're looking for, and by that point, I was smart enough to recognize it.

JR: *And so was Universal Press Syndicate!*

BW: Yes, thank heavens.

JR: *Did you get a development contract?*

BW: Not with Universal. United Features had given me one sometime earlier. I think they paid me a thousand dollars and gave me a six-month period to develop what became *Calvin and Hobbes*. If they liked it, they would then have the

exclusive option to syndicate it—the right of first refusal. I was very excited, since this was a big, well-known syndicate. They had *Peanuts* and *Garfield* at that time. But the top brass there didn't get excited about my work, and at the end of the six months, United turned it down. Crushed again. Later, when Universal took the strip, I even had to pay back the money!

JR: How closely were you working with the editor at United?

BW: I don't really remember. I'm sure there was some back-and-forth, but it was fairly distant. When the strip was declined, I don't think I had even been aware that the decision was imminent. I think they were just passing my ongoing work up the chain of command, and somebody finally pulled the plug. I heard afterward that Sarah had been a strong advocate for the work, but had been unable to persuade the higher-ups.

After that fell through, I sent the strip to the Washington Post Writers Group, because they had *Bloom County*, and I sent it to Universal, because they had *Doonesbury*. The Washington Post Writers Group rejected *Calvin and Hobbes* too. Everybody laughs at United now, but the fact is, *nobody* was thinking, "Ooh baby, this is gold."

Universal wrote back saying, "Hmm, send us some more." They weren't signing on, but they weren't rejecting it either. So this was not a contract of any sort; it was just "whenever you get a chance, if you feel like it, we'd like to see more strips." So two minutes after reading that, I called them to ask what they were looking for. I was a bundle of nerves, but I talked to a very calm, reassuring editor, Jake Morrissey, who I didn't realize until much later was my own age. He said, "We just want to see more of

what you do, so draw whatever you want." I didn't know what to think, but I drew another month's worth of strips, and that's when they took it.

JR: Did Calvin still have the bangs over his eyes at this point?

BW: Yes. I had already changed his name to Calvin, but I didn't change his appearance until right before he went into the papers—when I was drawing up the final work, the real stuff. In the several months between the contract and the launch, Lee Salem and Jake helped me pull together the strongest material, organize the presentation of the characters, and so on. I redrew all the work in the proper format, and we put together the sales kit of samples to take on the road to newspaper editors across the country. That part happened pretty fast.

I've tried to recall the moment when I got syndicated, and honestly, I don't remember much about it. I know I was thrilled and hopeful, of course, but it wasn't a break-out-the-cigars sort of thing. There was definitely this feeling of "time to light the rockets." Not exactly panic, but close. There were dogs on my heels. I didn't have a Plan B.

JR: Was Calvin and Hobbes *an instant success, or did it grow slowly? When did you know it was a hit?*

BW: I think the strip launched with about thirty-five papers. That's not a big start, but some of those papers were in large cities, so that was good. We gained some papers every month—maybe five or ten, I don't recall exactly. I never knew what the expectations were for a beginning strip, so I had no idea what kind of trajectory I was on. The famous strips were in hundreds or even thousands of

newspapers, so when Lee called to enthusiastically tell me I was up to fifty papers, I saw it was a long road to the big time. I believe *Calvin and Hobbes* made healthy progress that first year, but nothing extraordinary.

Things started to take off later in the second year, when the first book came out. With zero promotion on my end, the book somehow hit the best-seller lists and stayed there all year. The syndicate kept going back to print new editions. The next book came out a year later and pretty much did the same thing. Newspaper editors got a lot braver when they saw the books moving. That's when papers really started signing up and the numbers began to snowball. The strip owes much of its success to the books.

JR: *How did you develop the design of the strip's characters and the background, and how did that change over the years?*

BW: If I were going to come up with a strip now, I'd probably spend some time designing the major elements, in order to get a visual sense of the strip's world and to make sure the characters are attractive and animate well. I don't recall doing much of that, however, since it was more than likely that the submission would end up in the trash by the following month. I would just come up with something and go with it. I didn't fill notebooks with character studies or any of that.

As *Calvin and Hobbes* went on, the writing pushed the drawings into greater complexity. One of the jokes I really like is that the fantasies are drawn more realistically than reality, since that says a lot about what's going on in Calvin's head. So that, and my interest in creating a lively sense of animation, forced me to push the flatter, more cartoony and loose designs I started with into a more three-dimensional conception of form and space. If I wanted to draw Calvin from some odd camera angle, I had to visualize him sort of sculpturally so I could draw it. That's when you discover that the zigzag shorthand for his hair doesn't work in perspective very well. Or you find that his tiny little legs are hard to make run, because he hardly has knees. You invent solutions to these sorts of problems, and that gradually changes the appearance of the strip.

Another factor was simply that I got better at drawing as I went along, so I wanted to throw in whatever I was capable of doing. I kept trying to push the art as far as I could, because drawing was the fun part. I was eager to keep raising the bar and discover what else I might be able to do with the strip. By the end, I had a sort of calligraphic brush line I liked and I was very happy with the look of the strip. It looked like what I had in my head.

JR: *At the very beginning, why did you decide to make Calvin's stuffed animal a tiger, versus a bear, or some other animal? Was there a particular reason?*

BW: I don't think there was a lot of thought in that either. I wanted something less conventional than a bear. For Calvin, it should be a bit unusual. But I probably spent all of five minutes thinking about it. Once I hit on a tiger, of course, it was great—cats and I have a certain rapport, so this was a very natural fit for me. Maybe Hobbes could have been some other animal, but he arrived as a big cat, and that expanded my connection with him. Hobbes was as much my alter ego as Calvin was.

JR: *The emotional center of the strip is the relationship between Calvin and Hobbes, so looking back at the strip almost twenty*

years after it ended, what do you think was so special about their relationship, and why do you think it resonated so much with readers?

BW: Hmm. *(long pause)*

JR: *Well, maybe we should back up and you should describe what you think the relationship was between the two of them.*

BW: I don't know if I can describe it, and that's part of the fun of it. It wasn't something I deliberately constructed.

I remember very early on in the strip, Rich West said, "I think this strip is about friendship," and that sort of surprised me, because I hadn't thought about the strip on those terms. I never sat down with the intention of writing about friendship; I sat down to write about this little kid and a tiger, and the friendship was what came out.

The characters were very alive to me. I don't know if this makes sense to people, but when you're doing this right, you're not putting words into the characters' mouths. Instead, you're *listening* to them. They talk on their own, and you just follow along behind. The characters write their own material. And that's what happened—Calvin and Hobbes wrote their own material. Their friendship was not so much constructed as *revealed*. I just felt it. So that makes it a little hard for me to describe. But as a writer, not being able to neatly define this and put it in a box is a wonderful thing. It means the relationship is organic and alive. At some level, it's unknowable; it's just there.

As to why it resonates with people, I suppose I like to think that there's some sort of truth to it, but who knows. It's one of those things that's hard to take credit for, because I don't know if I could do it again, and I don't know quite how it happened the first time!

JR: *To me, the relationship has a certain authenticity in that Calvin and Hobbes don't always agree with each other. They clearly love each other and love to be together, but they annoy each other and argue too. It wasn't a one-dimensional relationship.*

BW: Right. I'd say the best relationships that I have personally are playful. So I hope the strip taps into the banter and arguments and the silliness you have with someone you care about.

JR: *You've said that Calvin's father is partly based on your own father and partly based on you. Which characteristics are more him and which more you?*

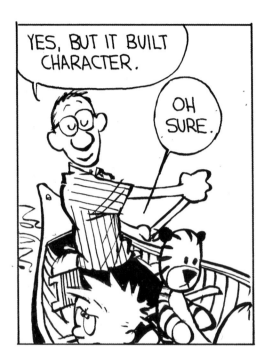

BW: Well, the running joke in the strip, where the dad talks about "building character," is my dad all through. My dad brought a lot of enthusiasm to his interests. He would read everything he could about the subject and he usually became somewhat expert at whatever it was. My brother is like that too. So I parodied my dad's passions. He had a European road bike back when *nobody* rode those. He ran marathons. I was dimly aware that other kids' fathers weren't exactly like mine. So a lot of Calvin's dad was an affectionate ribbing of my own dad, and he got a big kick out of it. I don't think he realized how odd he was until I put him in the paper. I'd draw him coming back from a run in the freezing rain, excited about eating oatmeal and prunes, thinking "Ah, this is the life!" and the joke is that there's no joke in that—that was my dad.

In all the more normal situations in the strip, I'd inhabit the dad character myself, just as I did with the other characters, and imagine how I would react to whatever the story was. So a lot of the dad character was me, too. It just depended on what the strip was about.

JR: *Did you actually go on family camping vacations?*

BW: Oh, yeah. One time, I can't remember where this was— they all sort of blur together— but we had paddled a canoe across some giant lake and camped overnight. While we were asleep, it snowed, and we were not prepared at all for that. We didn't have heavy clothes, everything was wet, it was hard to make a fire, and we were *freezing*. First thing out of bed, we went on a long trudge, just to get warm enough to eat breakfast. The day didn't improve, so eventually we packed everything in the canoe again and started paddling back across the lake. It was windy, the water was choppy, and we had to constantly point the canoe into the bigger waves so they wouldn't roll us. It was still snowing, it was getting darker, and we were miserable. We'd stick our hands in the lake because the water felt warmer than the air—but of course it's even worse when you pull your hand out again. Looking back, I'm fairly appalled at the risks we were exposed to. I had a lot of faith in grown-ups that might not have been entirely justified. *(laughter)*

Another time, we got lost and had to portage the canoe around what seemed like a hundred little waterfalls, while we ran out of food. Eventually we had to turn around, and portage a hundred times back *up,* for another late-night arrival. We didn't die, though, so I guess we built some character.

These sorts of things are—well, they're scarring, actually! *(laughter)* But they're experiences you can use later.

JR: *Calvin's family vacations were actually milder versions of what you experienced!*

BW: And there was no disaster bad enough that it would diminish my dad's enthusiasm for doing it again! *(laughter)*

JR: *When you drew* Calvin and Hobbes, *you weren't a parent. Now that you are one, what do you think about how the strip portrayed parenthood?*

BW: Well, times had changed since I was a kid, and not being a parent myself, I missed some of the memos. I drew a couple of strips where Calvin and Hobbes are sitting alone in the car while Calvin's mom or dad shops. My parents did that all the time when we were kids, but if you did it now, someone would call the police. I imagine today's readers wonder what's wrong with me that I'd draw something like that.

But generally, I'd say that Calvin was never intended to be a literal portrayal of childhood, so I took some license in his relationship with his parents. Also, the strip is mostly drawn from Calvin's point of view, so it's not an objective depiction of the family dynamic either. The parents hardly exist if they're not coping with Calvin.

And sometimes the strip had nothing to do with parenthood *or* childhood. Sometimes I used Calvin as a way to laugh at myself or whatever I happened to be going through at the moment. I could use him to process my own adult life.

Calvin was never just one thing; he could function in a number of different ways. If I was thinking about some issue in current affairs, I could use Calvin to talk about it. If I just wanted to do something silly, I could use Calvin for *that*. If I wanted to remember an incident from my childhood, he could do *that*. If I wanted to examine some issue in my personal life, he could do *that*. If I wanted to make something up completely, he could do *that*, and so on. As a writer, one of the real pleasures of the strip was its versatility. I wasn't stuck with just one approach. Juggling a lot of balls kept everything interesting for me, and presumably this would be more entertaining for the readers as well.

JR: *I think if Calvin had been a more literal six-year-old, it would have been limiting.*

BW: Right. And I wouldn't have known how to write that anyway!

JR: *Regular and constant deadlines are an unavoidable part of drawing a newspaper comic strip. Charles Schulz famously worked many months ahead, while Berkeley Breathed has said he worked "in a manic, sweat-swinging state of deadline panic every week." Which one were you closer to, and how did those relentless deadlines impact your work . . . and your life?*

BW: Typically, I tried to stay a couple of months ahead. I was always fairly organized and disciplined about it. Some of that was just what I regarded as professional behavior. I wanted my work in on time, without a lot of drama. I can generate plenty of stress myself—I don't need any extra from deadlines.

Also, I'm very aware that writing is a somewhat torturous process for me, and it takes me a fair amount of work to get what I'm after. If I don't have a decent lead time, I can't revise and edit the way I want to.

There was one time, during the licensing mess, where I lost my entire lead. Time off and reruns were not allowed in those days, so I was sending in my work week by week, making the papers' deadlines at the last possible second. Back then, nothing was digital, of course, so the syndicate printed hard copies and mailed them to the client papers. We were so close to the wire that the syndicate had to send the work overnight by FedEx. I had a lot of papers, so sending hundreds upon hundreds of FedEx packages every week cost us a small fortune.

The worst part was that I couldn't get out of the hole. It was a nightmare. I'd get a week sent in and I'd have absolutely nothing for the following week. It was all I could do to write and draw a week *within* a week. I was in a black despair, which of course is not the best frame of mind for writing a lot of jokes. I was absolutely frantic. I had to publish everything I thought of, no matter what it was, and I found that idea almost unbearable. A huge audience is wonderful until you're doing work you don't think is good.

My wife saw that I was in full meltdown, so we sat down one night and mapped out a rigid schedule. We just got mathematical about it. The first week I'd try to finish eight dailies instead of six. If I did that for three weeks, I'd be six ahead—a week's lead time on the dailies. From there, it was a rule that every four weeks I would try to send in five weeks of strips. Doing that, I was gradually able to recover my entire lead, but it took me half a year. That was a brutal lesson, and I never let it happen again.

Another time I had a bicycle crash, bruised a rib and broke a finger. Eventually I managed to prop a board on my knees so I could draw in bed, but there were a number of days when I couldn't work. Generally speaking, I had my life reduced to the point where absolutely nothing unpredictable ever happened, but it's good to have a buffer on the deadlines, just in case.

JR: *What was your typical work schedule like—a work day, or week, or month if that's how you conceived the schedule?*

BW: For the first two or three years my schedule was sort of all over the place, because I was mailing in roughs to Jake and Lee for approval, and the turnaround added at least a week and a half to the process. I worked a bit more haphazardly, doing whatever was most pressing.

I remember the later years better, after I got regimented. I mapped out each month. I always did the Sundays separately, because the color processing demanded earlier deadlines for those, so I'd often devote my weekends to writing and drawing Sunday strips. For the dailies, I'd book the first three weeks of the month for writing and the final week for drawing.

I needed all that writing time because my productivity was so variable. I might spend two days and write nothing, or I might spend a morning and write a week. Or I might write three strips one day and scratch them out the next morning. I never knew what to expect. It was impossible to budget, so I gave myself as much time as possible to cover for bad writing days, and to allow for constant editing and revision. But whether the writing went easily or badly, I'd force myself to have thirty daily strips written by the end of the third week. These would

be very tiny perfunctory doodles in a spiral school notebook, with the dialogue pretty well set.

In the fourth week, I just inked like crazy. If the strips weren't too complex, I could ink six in a long day, which would let me do the whole month in five days. I didn't have arthritis then, and I had a better back, so I'd just draw as long as it took. The drawing time was roughly quantifiable. I knew how fast I could draw, so I could plan that and, with luck, regain some efficiency. With the writing, I just never knew what would happen or how it would go.

JR: *Do you feel like you ever reached the point where you had a good work/life balance?*

BW: *(long pause)* Oh, probably not. Things are never so good that I can't make myself miserable. *(laughter)*

I was pretty driven. I wanted the strip to be better and better. I think my goal was to do a comic strip that was better written than I could actually write, and better drawn than I could actually draw. I appraised my work very critically, so I tended to focus on the flaws. You need to do that so you can fix things up, but being in the wormhole, grains of sand looked huge. I would go through these cycles of despair and elation based on the perceived quality of the strip—things that I doubt anyone else could see in either direction. It was all a bit manic.

JR: *It's interesting that you say that, because as I was reading through all the strips for this exhibition, one of the things that struck me was the consistency and the high level of quality throughout. I wouldn't be able to point to a period where I'd say "this is where he's coasting or really struggling."*

BW: Comic strips are so ephemeral that daily consistency is sort of the test. You might get lucky and knock one out of the park on Monday, but that doesn't buy you much credit for Tuesday. Everybody's already forgotten it. The measure of a comic is those "Tuesday strips," where you *don't* hit it out of the park. Proportionally those are going to be the vast majority of your work, so how good are they?

It was extremely challenging, fulfilling work. I was endlessly grateful and appreciative of that—and I still am—so I hope none of this sounds like I hated my job, because I absolutely loved my job.

My point is simply that there's no magic for the magician. Keep in mind that it took me hours and hours to produce a strip that people read in a few seconds. When creating the strip, there's a molecular attention that messes with your mind. My aspirations were very high for the work, and it was hard for me to step back.

Part of it was that I knew *Calvin and Hobbes* was my walk on the moon. This is what I had dreamed of doing since I was a kid. I not only got to draw a comic strip, but the public responded to it and it was successful. I felt indebted, like I owed the universe a lot. Having this rare opportunity was such a gift that I couldn't imagine compromising any part of it for any reason. This was never a business for me, and I couldn't care less if my positions seemed unreasonable. The intensity of pushing the writing and drawing as far as my skills allowed was the whole point of doing it. I eliminated pretty much everything from my life that wasn't the strip. My wife, Melissa, handled most everything to do with the real world, and I went at my work with a Captain Ahab–like obsession.

And the fact is, we didn't know how else to do it. I don't think I could have done the strip without isolating myself from the pressure and attention. Everything was so much bigger than we knew how to handle. My approach was probably too crazy to sustain for a lifetime, but it let me draw the exact strip I wanted while it lasted.

And I guess maybe I should add here that I stopped the strip for several reasons, and this imbalance was only one of them. Some people think I burned out, or that I quit because I was so angry about business compromises. Neither is true. For the last half of the strip, I had all the artistic freedom I ever wanted, I had sabbaticals, I had a good lead on deadlines, and I felt I was working at the peak of my talents. There was no crisis here. I just knew it was time to go.

By the end, I felt I'd reached the top of the mountain. The strip was as close to my vision for it as I was capable of doing. I was happy with what I had achieved, and the strip's world seemed complete. There's a point at which you realize that doing more doesn't add anything, and may actually make things worse. I didn't want to mow the lawn—just go back and forth over the same ground. Art has to keep moving and discovering to stay alive, and increasingly I felt that the new territory was elsewhere. That's partly why the last strip was about exploring. I had always assumed I'd draw cartoons my whole life, so in a way, I was as surprised as anyone. But it was the right decision.

JR: *So you ended the strip and left the world of cartooning in 1995. A decade later, you decided to place your collection of more than three thousand original* Calvin and Hobbes *strips, along with other materials related to your cartooning career, at The Ohio State University's Billy Ireland Cartoon Library & Museum. Why did you decide to deposit your collection at a research library, and why Ohio State?*

BW: Long ago, Rich West had recommended the Library to me. I met Lucy Caswell and was much impressed with her vision and scholarly professionalism. Some years after I stopped the strip, I wanted to get my work into a more protective, permanent environment, so the choice was a no-brainer. And now of course the Billy Ireland Cartoon Library & Museum is even more impressive. It's a remarkable institution, and the fact that this fabulous resource is right in my home state is icing on the cake.

JR: *The Library and museum are focused on preserving and providing access to materials documenting the cartooning art form for public viewing and research. How do you feel this arrangement benefits the public?*

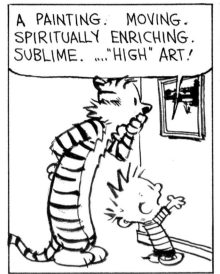
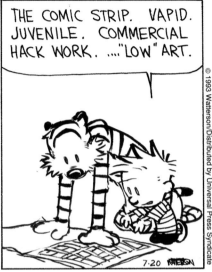
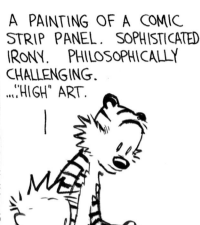
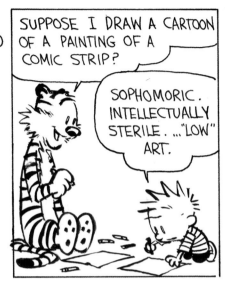

July 20, 1993

BW: I think the Library helps counteract the art world's condescension to the "low art" of cartoons, and it protects work that would otherwise be scattered or lost. In making original work available for anyone to study, it also gives us access to our own history. You know, if you're a painter, it's simply taken for granted that you'll spend a lot of time in museums studying great paintings, but if you're a cartoonist, it used to be very hard to see an original cartoon drawing.

When you see an original *Steve Canyon* daily strip—they're gigantic—it's an entirely different experience than seeing a newspaper or book reproduction. The scale of the drawing affects how we relate to it, and the images have a different impact when you see them as they were actually drawn. A big drawing sort of clobbers you; a small drawing pulls you in.

And comics are just paper and ink, so there's an intimacy and simplicity that I just love in the originals. Even the largest and most masterful drawings are very human and unintimidating. A cartoon original is not intended to be the finished product, so the artist can leave a fair amount of slop that never reproduces. You see the white-out and pencil lines and the places where the artist fixed up a spot or changed his mind about something. It's a little window into the artist's process, and if you love this art, it's quite inspiring. You get to see those moments of grace where the lines are confident, distilled, and flowing, as well as those moments when the cartoonist is struggling and bumbling like everyone else. It's wonderful to study the actual marks and re-create in your mind the human touch behind them. I think part of the power of any artwork is the physical presence you sense behind the creation. A real person made these things, and when you see the actual drawings, you can participate in that.

JR: *What types of popular culture were you consuming while you were drawing the strip? TV, movies, music, video games, comics . . . is there anything in particular?*

BW: Wow, not much. No.

JR: *Did you have time?* (laughter)

BW: Considering my career was *in* pop culture, it's kind of funny how little I generally have to do with it. I'm not thinking of anything influential.

Well, wait. In the early years of the strip, I got interested in looking at animation. Back then, with a video cassette player, you could freeze the frame of a cartoon video into a sort of fuzzy, jerky image. I'd do that and study the distortions when a cartoon character would launch into some extreme action. I guess *Roger Rabbit* resurrected everyone's interest in Tex Avery at that time. I don't like Disney cartoons, but I'd turn off the sound and just look at the way a character bobs his head and blinks while he talks—the faces are expressive, in constant motion, even when saying something ordinary. The Daffy Duck, Bugs Bunny, Yosemite Sam stuff is still my favorite. Rollicking, fun cartoons, and some of it is quite smart. As a kid, I was enthralled with Chuck Jones's Road Runner cartoons. Some wonderful landscape backgrounds in those. Obviously, in a comic strip, you can't duplicate a lot of what animation does, because the impact of the effect depends on how fast it happens—but I did try to learn from it, at least in the sense of conveying visual energy. So older animation was an influence.

And I guess there were a couple of years in the late '80s when I noticed some comic books. I was not plugged into that world at all, but I saw Frank Miller's *Dark Knight* version of Batman, which was the first comic book I'd read in more than a decade. That kind of violent bleakness is not to my taste at all, but it was an eye-opener in its reinvention of the character. I also remember paying attention to a few comic books illustrated by Bill Sienkiewicz that came out about then. Long before Photoshop, he painted and collaged and photocopied the artwork—all sorts of techniques I never would have thought of applying to cartoons. At bottom, they were still rooted in a superhero sensibility that did nothing for me, but his approach to materials was inventive. So I wouldn't say comic books had any real influence on me, but I was noticing that these were lavishly printed and that comic books were opening up in the sophistication of their writing and art. It made me wonder why that wasn't happening with comic strips.

JR: *Are there any non-cartoon influences, or any writers who were important to you for* Calvin and Hobbes?

BW: No, I'm shockingly ill-read. I'm not proud of this, but when faced with a work of fiction—a book, a movie, or anything—I tend to think, "You know, I've got problems of my own." *(laughter)*

I tend to prefer nonfiction, so that on the chance I understand any of it, I learn something. Since the strip, I've sort of cobbled together an art history background that way, just reading whatever interests me.

JR: *Do you want to talk about that?*

BW: It's mostly post–*Calvin and Hobbes*. I don't know if it relates to anything here, but okay.

JR: *Well, I'm interested in it. Who are some artists you've discovered?*

BW: Going way back, my college printmaking teacher introduced me to the drawings of Egon Schiele. There were virtually no books on him then, but he's pretty well known now. Lots of self-portraits and nudes. Wonderful draftsman, very perceptive line. From there, I got to like other German Expressionists, particularly the woodcut prints. Max Beckmann is a favorite. I suppose with these I respond to their graphic energy—bold lines, distortion, and a heightened emotional response to the subject. Not too far from cartooning.

Later, as I began painting more and more myself, I looked in every direction for inspiration or answers, so my path has been very meandering. I just followed whatever was new to me or intriguing, contemporary or old. I've liked Lucian Freud's work for a long time. A cold eye, but great sense of physicality and weight. But I've looked at most everything, at least to gauge my interest. If I liked it, I'd try out the part that interests me and see how it all works. I sort of moved backward through history, and eventually got interested in some of the Old Masters too. I like late Titian, Caravaggio, Rembrandt, and Vermeer, all for different reasons. I've read a bit about old painting methods and conservation issues too. It becomes intriguing when you've got a small stake in it.

And when you paint, you begin to understand the artists' decisions from the inside out. If you go outdoors thinking like an Impressionist, you'll quickly find that light is indifferent to your pictorial concerns. The central subject of your picture may be backlit or something. I think Whistler said Nature never painted a picture. In

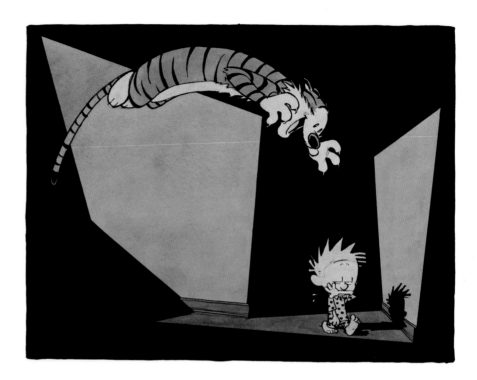

the Baroque, the light was artificially arranged, more like a theater spotlight. It creates a hierarchy of visual importance and directs your eye very purposefully, but it's unnatural, and it tends to glorify subjects in a sort of bombastic way. Every approach has its own strength and weakness, so you have to discover how these things work and decide what you're after. There have been a million puzzles to solve, and I don't know why, but they interest me. I just teach myself in the school of hard knocks.

And to come back full circle, studying painting has made me appreciate cartooning in a different way. Most painting up until modern times was narrative and symbolic and meant to edify, but I don't think painting does any of that especially well. If you're trying to communicate specific ideas or tell a story, I think cartooning is the stronger medium for the task.

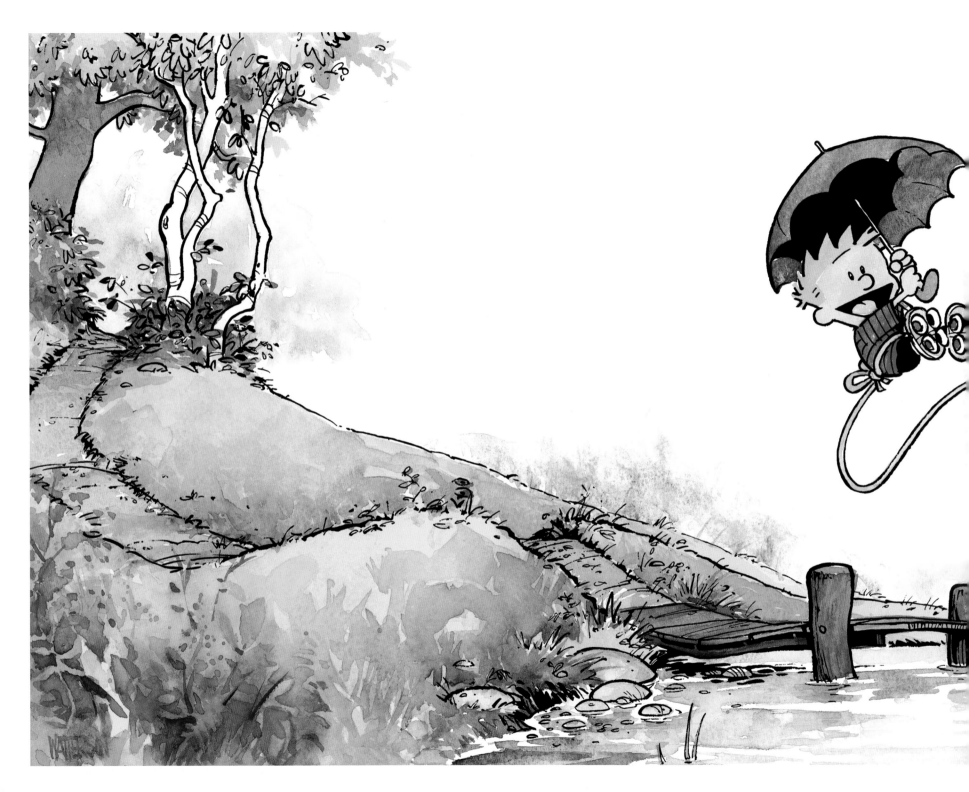

But I don't actually mean to argue for the superiority of any art. There's a wide array of art for a wide array of ideas. If you don't like somebody's work, go look at something else. There is an enormous range of human experience, and art exists so we can give voice to all of it. The silly distinctions we make are all convention and taste, and you don't need to look at much history to see how fickle that is.

JR: *Exactly. I often use the strip you did about "high" art and "low" art in my presentations about the Billy Ireland Cartoon Library & Museum to make exactly that point. So going back to* Calvin and Hobbes, *did you ever head down a path with the strip and then stop? Were there story lines or characters or jokes that you wrote but ended up not using?*

BW: Oh sure, many. It's hard to recall specific examples, but one time I had Calvin encounter some kid on the playground who was supposed to be weird or unpopular or something. I don't remember what I was trying to do with this, but I had written a couple of weeks of the story. I was vaguely aware that something wasn't working right, but I was reluctant to scrap that much work. Obviously, if you throw out two weeks of work, you not only have to rewrite it, but you lose more time by doing so, and you have to write even more just to catch back up.

Anyway, I wasn't confident about the direction the story was going, so I showed it to Melissa. She didn't think the story worked either, so I tossed the whole thing in the trash. Afterward I realized that having a kid weirder than Calvin changes Calvin's role in the strip. He was no longer the outsider. He appeared more bland and normal in comparison, and that undermines the whole

character. Schulz had a similar problem once when he put a cat in the strip. He decided the cat made Snoopy too much like a normal dog, so he abandoned the character. Anyway, I was annoyed at the wasted work, but it was a great relief that I never drew it up.

Fortunately, that sort of wholesale dumping was fairly rare. More often I could eliminate a couple of strips that had taken me down an unproductive path, or I could revise whatever was wrong as I reread the work with fresher eyes over the following weeks before inking.

To the extent possible, I tried to do a lot of weeding and fixing as I went along. I needed to write extra material to allow that, so again, a pretty good lead on the deadlines was important.

JR: *In* Calvin and Hobbes *there are almost no references to specific current events or people in pop culture. Why is that?*

BW: There are one or two, but early on I realized that was a mistake. References to current people and topics usually don't wear well, and basically, that stuff doesn't interest me anyway. I preferred to work with the larger issues underneath, not the surface clutter.

I'll say something else about writing the strip, speaking more generally. For the quantity of material you have to generate, you need to use absolutely everything that enters your head. And if something new doesn't come in, you've got to start tunneling into your own brain. It's a mining operation—it's excavation! *(laughter)*

On the good side, one of the true joys of cartooning is that it helps you live very attentively. It makes you think about what you think about. On the bad side, all that examination and analysis can make it hard to live in

the moment. You're always looking for a way to squeeze something useful out of whatever you encounter.

In the long run, staying fresh is sort of a losing battle, no matter what. Over time, the readers get cued in to the way you think, and they learn to read your pitches. They see it coming, and they're no longer surprised. The longer you work, the more you need to reinvent your strip, and that's a tricky thing, because new directions change the strip and change your relationship with the readers.

Schulz often added new characters, and I'd say the strip's focus and spirit shifted several times over the course of its long run. I read *Peanuts* with much less interest by the mid-'70s, and later characters, like Spike, frankly baffled me. Lynn Johnston's *For Better or For Worse* continually energized itself with new subject matter by aging the characters, but then one day the kids are grown up and it's not a nuclear family strip anymore. Obviously, my solution was to pack my bags and sneak out the door, but I was already wondering how many more times could I draw a dinosaur or Spaceman Spiff without boring everyone, including myself. It's something every cartoonist has to face. No matter what world you create, its limitations become apparent after a certain amount of time. You need to expand the world, or find a new world, or dig deeper into the existing world . . . something has to change.

JR: *Or the strip stagnates.*

BW: Which a lot of strips do, of course. It's a real dilemma.

JR: *That's interesting, because* Calvin and Hobbes *had a very small cast of characters. The ones you started with were the ones who lasted throughout. If you had continued the strip, I don't know what you would have done about that.*

BW: Changing that aspect would've been hard for me. I didn't exactly realize this when I started, but the small cast was one of the things that made the glove fit. It's very much true to my own life. The strip describes a very small world—or sort of the big world within the small world—so adding characters would start to alter all that. I doubt that's a direction I'd want to go.

On purely artistic terms, I might argue that a comic strip, like anything else, has a natural life span, as I was saying earlier. We all want to extend that life span, but after a point, the strip is on the machines and not breathing by itself anymore. Of course, in practical terms, I'm not sure most readers care, and it's unreasonable to expect a cartoonist to give up a nice livelihood just because the strip is a bit past its expiration date.

JR: *But in this context, the fact that you changed the formal constraints of the Sunday strip, and could change what you did visually with the layout and design . . . that must have helped expand what you were able to do.*

BW: It really did. All the new things I could do with the big Sundays made the work very exciting again.

The Sunday strips worked great for visual fireworks, while the daily strips worked best for long stories and small jokes. This had been the case all along, but the new format amplified the difference, so I usually did different types of strips for each of the formats.

Whenever I wrote a Sunday strip, I'd ask myself if the idea would work as a daily strip. If so, I'd cut it down

and make it a daily. My self-imposed rule was that the Sunday strip had to be something that would work no other way. So that generally pushed the Sundays toward elaborate drawings or ideas that required many panels. Now that I could draw strips like that, it changed my writing. I could do different kinds of ideas now. It was a whole new game, and I had a lot of fun with it.

JR: *Are you familiar with the OuBaPo movement?*

BW: No, I've never heard of it.

JR: *It's a French movement that encourages cartoonists to make comics with either arbitrary or very formal restraints to encourage creativity and push the boundaries of the medium. The newspaper comic strip is a perfect example of creating something with multiple constraints. How do you think the formal and technological constraints of the comic strip impacted* Calvin and Hobbes *positively and negatively?*

BW: Again, comics were sort of the language I spoke growing up, so I didn't question a lot of the limitations. Once the Sunday format opened up, I had all the freedom I wanted. Comics were always a comfortable fit for me—a natural way to express my ideas.

Since leaving the strip, it's been strange. In painting, there are virtually no constraints at all, and that leaves me completely flummoxed. I could paint something fifteen feet high or six inches high. I could blend and glaze and make it look like a photograph, or I could apply the paint with a trowel. I could work on a picture for a year, or I could finish it in two hours. I could paint what I see, or paint from my imagination, or paint abstractly.

I can do anything I want, and the more I learn, the more possibilities I have. That much choice incapacitates me. Every option has some benefit and some drawback, and I change my mind every half hour.

In hindsight, then, I have a lot more appreciation for the severe limitations of newspaper comics. It's going to be black and white, it's going to be ink on paper, it's all got to fit in this teeny little space, and it has to be done by yesterday. Okay, thank you, now I can get to work!

I think the hardest part is the deadline. But even there, I've come to respect it. A painting is infinitely perfectible, so I can't tell when to stop. The strip deadlines are so relentless that simplicity and speed become great virtues. The sacrificed options are just a given.

JR: *Without that deadline constraint, it wouldn't have been possible to complete so much work.*

BW: Right. You have to have limits. But with painting, it's hard to set up constraints without wrestling with the arbitrariness of it. Why would I choose this set of limitations over that set? It's good to have somebody to blame.

JR: (laughter) *That's interesting.*

BW: It's pathetic! *(laughter)*

There's a "painting a day" movement in blogs and so on, where the speed of the work determines the scale and potential subject matter. I can understand the impulse behind it.

JR: *Do you have any plans to exhibit your post–Calvin and Hobbes paintings?*

BW: Well, never say never, but I don't currently paint with that kind of ambition. I've been doing it more as a learning process. I don't harbor a lot of illusions about having something novel or significant to say as a painter. I just mess around with it because it's interesting.

JR: *You once said books actually do the best job of presenting your comic strip, since they allow the work to be printed larger, in the format and sequence you intended, with better color printing, and so on. How do you think reading the strip for the first time in a collection—which is how most people now are reading it— changes the experience, from reading it every day in a newspaper?*

BW: When I was talking to Richard Thompson about strips we liked as kids, it turned out we both read *Peanuts* and *Pogo*, but our parents happened to buy the paper that didn't carry those strips, so we read those strips in books. So even back when each city had several newspapers, our favorite strips weren't a newspaper experience. *(laughter)* What does that say about the importance of newspapers?

But the great thing about a book is that it lets you get immersed in the world of the strip in a way that you don't get in day-to-day installments. Reading a newspaper, it may take months or a year before you're really in the flow of what's going on in a comic strip. With a book, you can read weeks of strips in a sitting, so you're very quickly in sync with the cartoonist's world. Books are a great way to present comics, even beyond the layout and printing considerations. And I much prefer reading a book to scrolling around on a glowing screen, too.

JR: *So have you ever thought about doing a longer-form comic that would be presented for the first time in book form?*

BW: Well, I've thought about it, but if I have a graphic novel in me, it's certainly been slow to reveal itself. I suspect I'm not that kind of writer. I don't really think of big-concept stories that need longer treatment.

Actually, Richard Thompson talked about this with me too. He said he likes to work with small things he notices—and his example was "gravel in the street." *(laughter)* That might be a little *too* small, but I agree with him. Daily minutiae are not actually trivial. It's a wonderful thing to draw your attention to tiny little moments and small episodes. There can be something simple, grounded, and true when you observe those generally unnoticed small things. I tend to like that scale. Whenever I go to a computer-animated movie, I think, "Oh, please, not another quest." You know, must we always journey to discover ourselves, find home, and save Christmas? *(laughter)*

JR: *Has your position on the issue of licensing changed at all over the last twenty years?*

BW: No, but my view may not be quite as extreme as people think. My argument was really about artists' rights. I was saying the issue should be decided by the artist who created the work, and not the syndicate or anyone else. The artist gets to decide what his own creation is about and stands for. If licensing fits your vision of your creation, wonderful, go nuts. But I reserve the option of saying no for my own work. If I don't like licensing, I should be allowed to refuse it. That's all it was.

JR: *Are you surprised that the strip continues to enjoy such immense popularity so long after you stopped drawing it, and do you have any thoughts about why it's had such lasting impact?*

BW: It seems the less I have to do with it, the higher the strip's reputation gets! *(laughter)* So, no, I don't understand it at all.

I honestly assumed that the books would go out of print within a few years, once they didn't have the strip in the newspaper to create the readership for them. But people kept buying the books anyway, and now parents are showing them to their kids, and a new generation is coming up reading the strip. That's something I never anticipated at all.

As for why it continues to speak to people, I don't really know. I always tried to make the strip entertaining on several levels, so one aspect might appeal even if others don't. But really, I was writing to amuse Melissa and myself. That's as far as I understand.

JR: *When you look at comics today, in the newspaper, or in books, or online—assuming you do—do you see anything that excites you? Do you see any reason to be optimistic about the future of the serial comic strip in digital platforms?*

BW: I don't really read comics online. Since I don't participate in social media, I don't have a curating group to cull the sea of garbage for me, and I'm not willing to spend the time doing that myself. And frankly, even if someone were to recommend a strip to me, the work would really have to knock me for a loop before I'd go out of my way to dig through an archive of it or follow it regularly.

This has made me realize how passive the newspaper experience was. I'll read thirty comic strips a day for decades on end if an editor selects them, puts them together on a page, bundles them in with other things I intend to read anyway, and hires someone to toss it all on my doorstep. That whole package of content is worth something to me, partly because it comes preassembled. But no one part is valuable enough to me that I'd seek it out for its own sake. I like comics more than most people, but I don't want to personally scavenge for them.

Everything has changed, though. Clearly, for a lot of people, newspapers have become an absurd relic. People want a constant river of content and comment delivered to their devices all day, wherever they are. They're plugged into social networks and are constantly

bouncing around the Web for a moment's diversion anyway. For them, an online comic strip is not only more convenient, it's the only option, because newspapers aren't even in the mix. Obviously, comics need to be where the readers are.

But I do think it's harder for a new strip to win you over online. That day-in, day-out newspaper routine is gone and webcomics may not even update regularly. It takes a fair amount of time to get to know the characters, figure out the backstory, and get in the spirit of the strip's world. The online experience doesn't do much to support that kind of reader investment. There's too much else to look at and do. Now it's all speed dating—okay, it's been five minutes, are we in love yet? Sorry, probably not.

So there are still some serious bugs to work out. And we haven't even talked about money.

JR: *But there are some Web cartoonists who have figured out a successful business model and how to make money.*

BW: Yes, but as I understand it, the new business model is to put the strip out there for free, attract some zealous fans, and then hope to sell ads, or T-shirts, or original drawings, or book collections to make the actual income. You basically put your art out there as a loss leader. Even if it works, wow, that's depressing.

Apparently some cartoonists have done well that way, but I have to wonder if generally we've lowered the bar to the point where you're considered a success if you can move out of your mom's basement. I don't think we're talking about the kind of success newspaper cartoonists used to have.

JR: *Right. I don't know that very many Web cartoonists are "Milton Caniff" successful, with the big house, personal secretary, and live-in maid. It is a different standard. But people have built very successful businesses around their online comic.*

BW: At the low end of the business, where cartooning is mostly a hobby, being online is all good. You don't need anyone's permission, you can do everything yourself, you can say whatever you want, and you can find readers instantly. Maybe you can even make some money. That's all much better than it used to be. But for a career in cartooning, the ladder doesn't go up as high now. The mass media collected audiences and the Internet disperses audiences. I don't see how a cartoonist can have a big mainstream success anymore.

Newspaper strips were once read by tens of millions of people every single day. Everybody in America knew who Popeye was. You simply can't compare a webcomic on those terms—there's no equivalence whatsoever: the difference in readership is exponential. And without the mass media, I'm guessing that comic strips will lose most of their cultural impact.

I'm not criticizing webcomics. I'm happy they exist, I'm glad they're expanding the range of voices in comics, and I wish them nothing but success. I'm just sorry that we're losing the immense readership, the high incomes that come with that, and the chance to impact the culture.

Of course, I don't suppose anyone under the age of fifty will ever miss newspaper comics. I certainly never missed the radio serials that my parents enjoyed. Nobody laments the loss of what they don't use.

JR: *But there is something you lose when you no longer have a shared culture. When I'm talking to people now, I can't assume they read the same comics that I do.*

BW: And you can't assume that they listen to the same music, or watch the same TV shows, or anything. It's all atomized. There's little cohesive effect to pop culture anymore.

JR: *And is that a good thing or a bad thing? It's a hard question.*

BW: Exactly. We need to remember that all of America used to watch *Gilligan's Island* too. Are we saying that's what we want holding our country together? *(laughter)*

JR: *Do you still get a newspaper?*

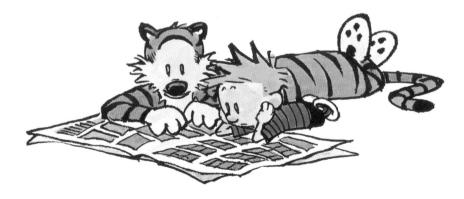

BW: I do. I'll probably be the last American reading one. You can tell I've gotten old. The Cleveland paper offers home delivery only a few days a week now, so I often read the newspaper on a tablet, but to be honest, I find reading on a screen a pretty annoying experience—all the scrolling, clicking, enlarging, closing, opening—blaughh. As visual as comics are, they are still basically reading. It's hard to make everything clear and attractive on screens of all different shapes and sizes. So far, I find it clunky and graceless.

Obviously families don't sit at the breakfast table passing around the funnies anymore. I don't think comics are going away, but our relationship to them is different now. We've lost the daily ritual and comforting routine that made comic characters feel like familiar friends that we expect to see every day, year after year. Our connection to comics is getting more fleeting and superficial.

Not only that, but the sheer glut of content online devalues everything. You can have anything you want, you can have it right now, and it's all free. That makes everything disposable. As consumers, we're ecstatic— we've finally busted down the door to the candy shop. But that's not so good for the guy making the candy. If your artistic product can be digitalized and put online, there is no protecting it and your labor becomes valueless. That's the ugly side of all this. When we don't pay for what we consume, we're exploiting people's talent and hard work.

And while we wait for the economics to get fixed, I wonder what the decline of mass media will mean in terms of attracting new talent to cartooning. If I were fifteen now, I don't know that I'd be thinking about comics. If the audience, the prestige, and the money are elsewhere, I'm guessing young talent will go elsewhere too. I think talent gravitates toward the places where it

can have the most impact, and the places where there's real reward for the work. That may no longer be comic strips in the years ahead.

I don't think comics are in any danger as an art. They may even get more interesting, now that less mainstream approaches can get published. But if comics are just a tiny, barely profitable sideshow for a few like-minded enthusiasts, cartoonists will have lost a lot in that bargain.

JR: *For the most part, you've declined interviews and public appearances in favor of letting your work speak for itself. What prompted you to stay out of the spotlight during, and since, the run of the strip?*

BW: I guess the simple answer is that I don't have the right temperament for it. The attention makes me very self-conscious and wary of people's motives, so I find the whole thing enervating. It's not a normal way to live. I don't trust it, and I don't enjoy it. The strip was plenty hard to do already, so I got ruthless about intrusions and just shut everything else out.

Most people are fine with that, but there's always a few who take it as a personal affront. "What, I buy your damned book and you won't take my phone calls?"— that sort of thing. *(laughter)* Or the press thinks, "If he won't talk to us, he must be hiding something pretty interesting." It was too much to deal with, and I didn't like it in the first place, so I cut it all out.

The problem, of course, was that I then had to spend a lot of energy building and maintaining a fortress around myself. Maybe there would've been a smarter way to handle it, but I couldn't think of it, and this seemed to be what I had to do. It was sort of a no-win scenario, and

just one of the more bizarre aspects of my job. Eventually, I developed a reputation as a hermit recluse, and that's worked so well in my favor that it's something I continue to try to live up to. *(laughter)*

JR: *Let's talk about some of the themes and strips featured in the exhibition. I find it interesting, given how much the seasons feature prominently in the strip and provide a kind of structure and a rhythm to it, that you were living in the desert at the time you created these strips. Were the seasons something you thought about while you were developing the strip, or is this theme just something that evolved over time?*

BW: Well, it's sort of a way to structure the year as you're writing. Certainly I was thinking of Ohio as the setting. And because I was writing ahead of when the strips appeared in the newspaper, this was a way to organize myself a little. I'd think, okay, this is coming out in November, so what would be going on then? And I'd recall those dark, dreary days when there may be a few snowflakes in the air. I actually kind of like that time of year now, but I didn't as a kid. So that might make me think of how it's cozy inside, and I might write an idea about Calvin not wanting to get up and go to school or something.

We talked earlier about timelessness, and using the seasons was also a way to keep things from getting too generic. You think of a strip like *Pogo*, which takes place in a Georgia swamp, and there are no seasons depicted— there's a remove from day-to-day life in that. I like how the seasons ground you in the physical world a bit. The seasons have moods, and I'm pulled by those. The spirit of each season offered different possibilities for ideas, and that was the main thing.

WELCOME TO STUPIDOPOLIS ...

In a way, I think *not* being in Ohio at the time concentrated those ideas. Memory distills your thoughts to what's important. The things you remember best are moments that triggered some emotion.

JR: *Looking at a detailed strip like the Sunday about Stupidopolis, which is included in the Summer section, did you use references for drawing?*

BW: Sometimes, sure. Architecture does not play to my strengths as an artist. Straight lines, rigid forms, technical perspective . . . I can do it, but a little goes a long way for me.

Back then there was no Google, so I had found an interesting book on a remainder table that was full of photos from low-flying airplanes as they went over all different kinds of landscapes, and it was helpful. I didn't want recognizable specifics, but the photos helped remind me of how streets and buildings are put together. You think you know what things look like until you sit down to draw it. Then you realize how unobservant you really are. What's on the roof of a skyscraper, and those sorts of questions.

It's weird—if I'd had Google Image back then, I don't know how I would have ever finished a strip. There's so much information right there that you almost feel obliged to look everything up. You want to draw a shark? Well, what *kind* of shark? Would you like it head-on, or side view, or maybe seen from slightly above and to the left? Back in the '80s, I'd just make it up. Draw a tall dorsal fin and a lot of teeth, and you've got a shark. That's still more my idea of cartooning. At its best, cartooning is truer than realism.

JR: *We only had room to put one of the stories in this exhibition, but maybe you can talk a little bit about the process you had for writing longer stories and how you were able to use that in advancing the strip.*

BW: On the whole, I tried to use the longer stories as relief from the daily jokes, and the daily jokes as relief from the longer stories. I think it's important to shake up the pace of the strip, so it's not one thing all the time. That gets sort of numbing. The more variety you have, the easier it is to keep things unpredictable.

I don't think I appreciated the stories at the time quite as much as I do now. I had a mixed reaction to writing them. As a practical matter, the stories sometimes helped on deadlines. The developing plot would create some writing momentum. Once you got things happening, each event would suggest consequences, or new possibilities, and sometimes the writing went faster as a result.

But as I was saying earlier with regard to graphic novels, writing an extended story takes a bigger engine, and I sort of resented cranking up a motor. Developing a big plot usually felt contrived. You've got to organize it, and there's a certain amount of scaffolding you have to set up to shape a longer series of events. You have to unobtrusively remind readers what's going on, set up the tempo, plan the dramatic moments, and everything has to aim for a satisfying resolution. All this felt a bit forced and artificial, so I found them hard to do. Or maybe I should say it was hard to do one that satisfied me. The stories I liked best had an organic, rambling, who-knows-where-this-is-going feeling—almost an anti-plot—but I couldn't summon that kind of idea very often.

Back on the positive side, I definitely recognized that stories help expand the characters' personalities. The character may deal with some vexation in a daily joke, but it's very abbreviated, and little is at stake. With an extended story, the character really grapples with his dilemma. You see him process alternatives and consequences. It's much more revealing, and you get deeper insight into his personality. He becomes more rounded and real. And I think when that happens, the reader invests more in him emotionally.

A story also lets you develop the relationship *between* characters. When this worked well—when the characters were really bouncing off each other, with their personalities on full display—it could really make me laugh. That was a lot of fun. Things would happen, or the characters would say things, that I *never* would have thought up otherwise. That kind of surprise made writing a delight.

So the stories were hard for me to pull together, but I've come to believe that they were among the most crucial parts of the strip. It's one thing to make a joke or a clever observation, but it takes the humor to a different level when the character is truly vulnerable or when events carry him to new places. You get attached to the character in a much deeper way. That's great as a writer, and it's great as a reader. With that deeper identification with the character, even the silly observations or jokes afterward have greater resonance.

JR: *In the exhibit, we focused on several devices that you used frequently, including Spaceman Spiff. The later strips often featured spectacular canyon landscapes.*

BW: In a Sunday strip, I'd always start by asking myself what I felt like drawing. I drew a lot of landing and flying scenes with Spaceman Spiff, simply as an excuse to draw that landscape. My brother and I like to roam along canyon rims with these immense lunar views below us. We're both ludicrously afraid of heights, so our excursions always have this weird mix of exhilaration and crippling fear.

I love the skeletal aspect of the landscape out there and the massive scale and vastness of everything. You're reminded that we're on a planet, that we're just little specks, and Nature will kill you if you're stupid. Somehow I find all that deeply comforting. *(laughter)* That's my church.

JR: *Well, it seems to have a great allure to cartoonists, going back of course to George Herriman.*

BW: And Jimmy Swinnerton painted it.

JR: *Swinnerton, yes. I'm wondering why the stripped-down landscape appeals so much.*

BW: It's an alien-looking place. Some people see it as a barren wasteland, but I loved it as soon as I saw it. The rocks are sort of maroon and ugly, but as your eyes get acclimatized, you see all these beautiful purples and reds and oranges. So it interested me with painting too. The weird columns of rock are easy to anthropomorphize, and everything is gargantuan. It's a bizarre place, and still a little bit wild and hostile to life. All that feeds the imagination, I think.

JR: *One section of the exhibition features some of your commentary about issues like mass media and its influence on society or the negative impact of humans on the environment and other species. What prompted you to tackle these bigger issues through the strip?*

BW: I guess those fall under the category of using the strip to process whatever I was thinking about. Calvin was always a good character for venting my outrage. And I think environmental issues in particular are fundamentally about our children.

JR: *We have a number of strips in the exhibition that deal with the meaning of life.*

BW: One of the beauties of a comic strip is that people's expectations are nil. If you draw anything more subtle than a pie in the face, you're considered a philosopher. You can sneak in an honest reflection once in a while, because readers rarely have their guard up.

I love the unpretentiousness of cartoons. If you sat down and wrote a two hundred page book called *My Big Thoughts on Life*, no one would read it. But if you stick those same thoughts in a comic strip and wrap them in a little joke that takes five seconds to read, now you're talking to millions. Any writer would kill for that kind of audience. What a gift.

JR: *Is that something you miss? Having that opportunity?*

BW: Yes, I do miss that.

JR: *It's been almost twenty years since you ended* Calvin and Hobbes. *Is there any chance you'd consider returning to comics? What's next for you?*

BW: I really don't know. Any new cartoon project would have to be pretty different and unexpected to get me excited about it. I'm not interested in repeating what I've done. If I felt strongly about the idea, I'd try to find some way to make it happen, but obviously I haven't pushed to find those ideas. For the moment, my quiet family life is the priority. We'll just have to see.

EXPLORING CALVIN AND HOBBES

"I think comics are something like folk art—sometimes breathtakingly kitschy, sometimes kooky and charming, and once in a while, as interesting and significant as any 'fine art.'"

—Bill Watterson

BILL WATTERSON'S *Calvin and Hobbes* is one of the most popular and accomplished comic strips of all time. From 1985 to 1995, Watterson's engaging characters, his thoughtful and original writing, and his creative layouts demonstrated what was possible to achieve within the constraints of the daily newspaper comic strip. His comics are beautiful to look at and a joy to read, and remain as interesting and significant as when they first appeared.

The strip revolves around six-year-old Calvin and his trusty companion, Hobbes. From Calvin's perspective, Hobbes is a real tiger, but to everyone else he appears to be a stuffed animal. The idea that different people perceive the world in very different ways is one that Watterson frequently explored. *Calvin and Hobbes* is a reflection of Watterson's own childhood combined with the thoughts, humor, struggles, and values of his older self. He wrote and drew every strip, so it is a deeply personal story. At the same time, the themes and ideas are universal. Through his characters, Watterson carried on a ten-year daily conversation with his readers about human relationships, art and popular culture, our place in the natural world, the importance of imagination and play, and the meaning of life.

This exhibition offers fans a chance to revisit and rediscover *Calvin and Hobbes* along with Watterson's unique voice, which is still relevant almost twenty years later. As Calvin says in the very last strip, "It's a magical world, Hobbes, ol' buddy . . . Let's go exploring!"

Curated by Jenny E. Robb

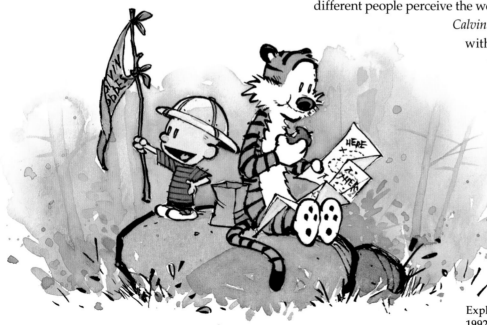

Explorers, *Indispensable Calvin and Hobbes*, 1992, watercolor on paper

INFLUENCES

BILL WATTERSON was influenced by a wide variety of accomplished

cartoonists throughout his career, including comic strip creators, editorial

cartoonists, and illustrators. This section of the exhibition includes works

Watterson chose from the collections of the Billy Ireland Cartoon Library &

Museum, along with his insights into how each artist's work inspired him.

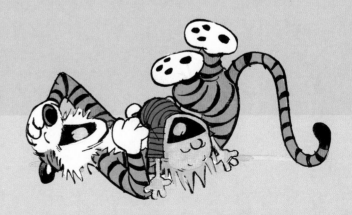

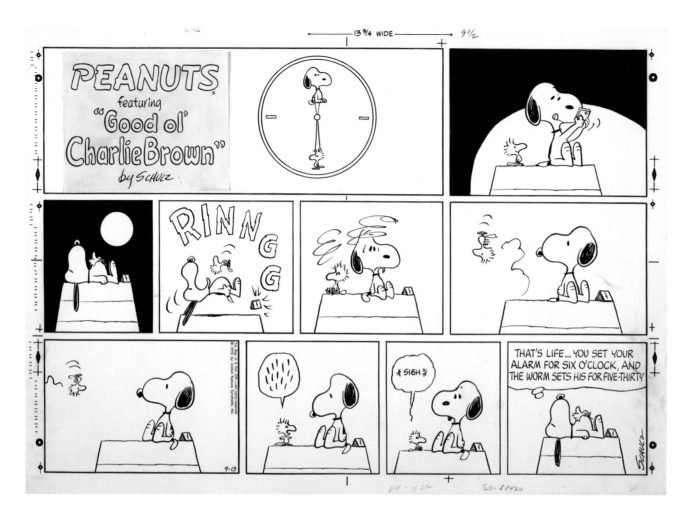

Charles Schulz, 1922–2000
Peanuts
September 13, 1970
Ink on paper
International Museum of
Cartoon Art Collection

"*Peanuts* made me want to be a cartoonist, and it largely defined my idea of what a comic strip should be: funny, beautifully drawn, expressive, and intelligent. In the '60s, as I was growing up, the annual *Peanuts* collections were one giant cartooning class for me.

"Perhaps the biggest influence that Charles Schulz had on me was that, back in the days when most every successful comic strip was produced to varying extents with assistants, Schulz wrote and drew every strip entirely himself. This standard of craftsmanship and writing integrity made a huge impression on me. You could tell the strip was one man's personal vision and not a committee production—it was a weird strip, and the weirdness was what made it great."

—Bill Watterson

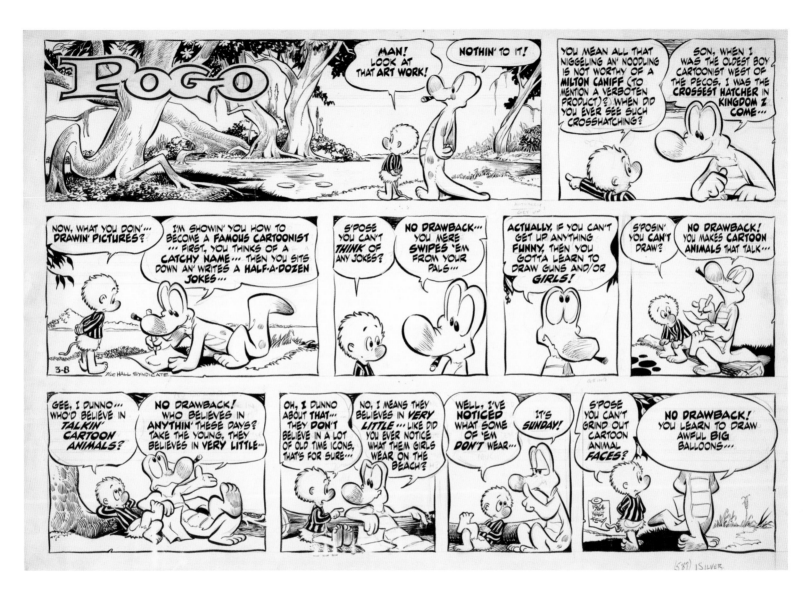

Walt Kelly, 1913–1973
Pogo
March 8, 1964
Ink on paper
Milton Caniff Collection

"Walt Kelly's flowing brush line was a marvel to me when I discovered the strip as a kid, and I loved the wonderful animation in all his drawing. *Pogo* was a garrulous strip full of vivid personalities, and their rambling, conversational dialogue made every panel funny, not just the last one. *Pogo* brimmed with exuberance and life, and its Georgian swamp was a world in itself. These were all qualities I greatly admired and tried to learn from."

—Bill Watterson

George Herriman, 1880–1944
Krazy Kat
January 18, 1942
Ink on paper
International Museum of Cartoon Art Collection

"Peanuts and *Pogo* shaped my ideas of comics when I was growing up, but *Krazy Kat* was probably the most important strip to me when I was working. The bold, graphic designs of George Herriman's astounding Sunday pages were a big reference when I was finally able to lay out my Sunday strips without restrictions. But more significantly, *Krazy Kat* also made me more attentive to the use of language, timing, and space—the 'poetry' of it all. *Krazy Kat* is a loving exploration of comic strip form, and the deeper I got into my own work, the more I found in *Krazy Kat* to inspire me."

—Bill Watterson

Alex Raymond, 1909–1956
Flash Gordon
November 22, 1936
Ink on paper
Charles H. Kuhn Collection

"*Flash Gordon*'s cheesy, costumed space drama is a guilty pleasure. The women rarely fail to wear something clingy and low-cut, and Flash's bare-chested heroism, described in admiring wonder, is delightfully ludicrous. Alex Raymond's cinematic glitz and deco spectacle is unquestionably a high point of newspaper comics, but what stayed in my mind was the grandiose, self-righteous quality of the moral drama, which seemed perfect for Spaceman Spiff's breathless descriptions of his own exploits."

—Bill Watterson

Garry Trudeau, 1948–
Doonesbury
August 19, 1971
Ink on paper
Milton Caniff Collection

"*Doonesbury* did not influence me as directly as other strips, but the intelligence of the writing, the sharpness of its cultural critique, and the warmth and compassion of its characterization demonstrated how wide-ranging, smart, and principled a comic strip can be. Garry Trudeau helped break down the public expectation that comic strips were childish fluff, and his seriousness of purpose in the art form was a great model to me."

—Bill Watterson

BLOOM COUNTY

182

by Berke Breathed

182

Berkeley Breathed, 1957–
Bloom County
September 10, 1982
Ink and pencil on paper
Bill Watterson Deposit Collection

"Bloom County was silly, frequently sophomoric, and utterly unpredictable. In the safe and staid comics pages of the early '80s, I found *Bloom County*'s anarchy a delight. Berkeley Breathed made the comics page a little wild and woolly at the edges, and an exciting place to be. That spirit of change was something I wanted to be part of, and it kept me working hard to make my work as lively as I could. Perhaps because Breathed was my own age, *Bloom County* felt like a fun rival strip, and I used it to spur myself on."

—Bill Watterson

'YOU BOTH SEEM TO HAVE LOST SOME WEIGHT SINCE I SAW YOU LAST!'

Pat Oliphant, 1935–
"You both seem to have lost weight . . ."
Denver Post, 1974
Ink on paper
International Museum of
Cartoon Art Collection

"Pat Oliphant has an enormous range of skills. His biting humor and powerful drawings shaped the entire political cartooning field. Oliphant's brushwork is simply masterful, and he can coax any mood and texture from it. His caricatures are great likenesses, mean but cartoony. Often he sets up evocative environments full of funny incidents and details that are worth poring over long after the cartoon's point is made. Besides the sheer virtuosity of his work, Oliphant shows the expressive variety possible in a drawing, and I, like many cartoonists, learned a lot from him."

—Bill Watterson

Jim Borgman, 1954–
"Where's Dessert?"
Cincinnati Enquirer, 1989
Ink and screentone on paper
Bill Watterson Deposit Collection

"Jim Borgman is another of those rare cartoonists who seems to be able to do anything. These days, he's probably best known for his lively artwork in *Zits*, but his editorial cartoons of some years ago were marvelous too. All his work is nuanced, thoughtful, and—needless to say—beautifully drawn. I met Jim when I got to college and he had just started at the *Cincinnati Enquirer*. His skills were light years beyond mine, and I suddenly realized I had a lot to learn. Jim's talent awed and inspired me, his example stoked my ambition, and his kindness and perceptive thoughts on all aspects of cartooning have been of inestimable value to me through all the years I've known him."

—Bill Watterson

Ralph Steadman, 1936–
[Self-caricature]
1989
Ink on paper
Mark J. Cohen and Rose Marie McDaniel Collection

"The extreme emotional register of Steadman's drawings
astonished me when I discovered them in my twenties.
The monsterish distortions, the violent, crude pen strokes
juxtaposed with thin and rigid ruled lines, the explosive ink
splatters—the marks themselves expressed horror, outrage,
and contempt. Steadman is not the guy you'd want to illustrate
Winnie the Pooh, but his work was a revelation in the intensity
that pen and ink can give voice to, and I learned a great deal
from it."

—Bill Watterson

EARLY WORK

DURING COLLEGE, Watterson contributed cartoons to his school's

newspaper, the *Kenyon Collegian* and yearbook the *Kenyon Reville.* After

graduating, he briefly worked as an editorial cartoonist for the *Cincinnati Post*.

He also created cartoons for Sun Newspapers, a chain of weekly suburban

newspapers in Cleveland, Ohio. He continued to draw for them even after *Calvin*

and Hobbes had launched. Notice the election cartoon dated 1986, which shows

a woman who looks just like

Calvin's teacher, Mrs. Wormwood.

—Sun Newspapers,
1986, ink on paper

—Self-caricature, Sun Newspapers,
1978, ink on paper

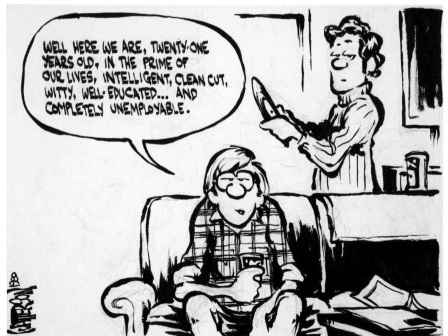

—*Kenyon Reveille,*
1980, ink on paper

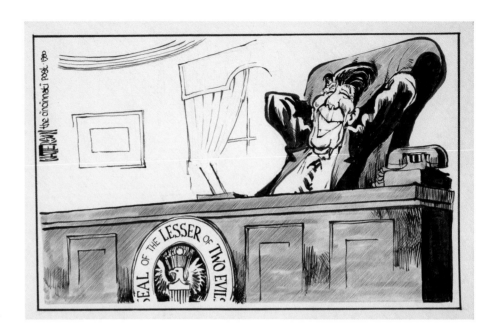

—*Cincinnati Post,*
1980, ink on duotone paper

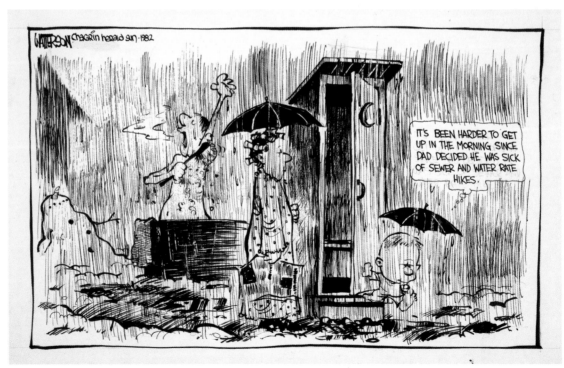

—Sun Newspapers,
1982, ink on paper

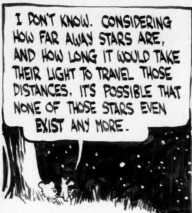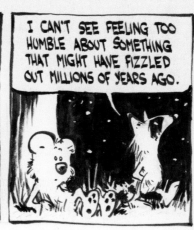

The comic strip panels read:

Panel 1: AREN'T THE STARS BEAUTIFUL TONIGHT? ..IT'S HUMBLING TO LOOK OUT THERE, AND PONDER THE MYSTERIES OF THE UNIVERSE..

Panel 2: I DON'T KNOW. CONSIDERING HOW FAR AWAY STARS ARE, AND HOW LONG IT WOULD TAKE THEIR LIGHT TO TRAVEL THOSE DISTANCES, IT'S POSSIBLE THAT NONE OF THOSE STARS EVEN EXIST ANY MORE.

Panel 3: I CAN'T SEE FEELING TOO HUMBLE ABOUT SOMETHING THAT MIGHT HAVE FIZZLED OUT MILLIONS OF YEARS AGO.

Panel 4: ...THANK YOU, MODERN SCIENCE.

Dear Mr. Yates:

Enclosed is a sample of a comic strip called "Critturs" that I would be grateful if you would consider.

If I can be of any help, please contact me at the above address.

Thank you for your time,

William B. Watterson

William B. Watterson

Well done in a Kelly manner & we considered carefully but finally decided to pass. We are already heavy on animal characters. Thanks — B.Y.

EARLY COMIC STRIP PROPOSALS

In the early 1980s, Watterson developed various comic strips to submit to the syndicates before finally achieving success with *Calvin and Hobbes*. One of these, titled *Critturs*, featured a cast of animals. In his note declining the strip, one syndicate editor commented that it was well done, in the style of Walt Kelly. Another strip proposal included a boy called Marvin who had a tiger friend named Hobbes. One of the syndicates passed on this strip but encouraged Watterson to create a strip focused on the kid character, which eventually became *Calvin and Hobbes*.

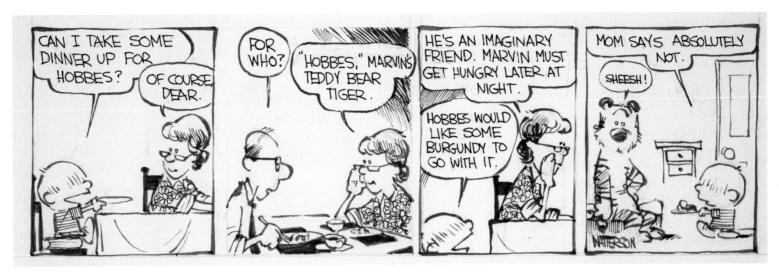

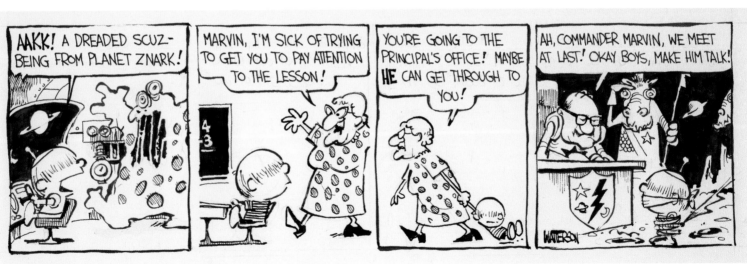

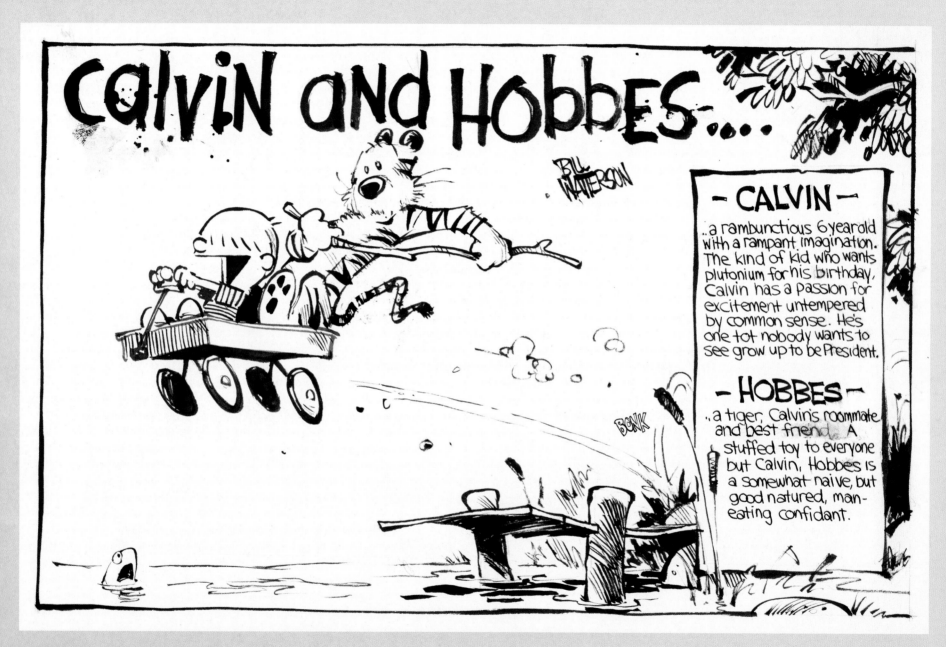

Calvin and Hobbes syndicate submission cover page, circa 1984

GETTING SYNDICATED

IN THE original version of *Calvin and Hobbes* that Watterson submitted to the

syndicates, Calvin's hair completely covered his eyes. Watterson credits his

editor at Universal for suggesting that he might want his central character's eyes

to show. He redrew the strips and gave Calvin his signature spiky hairstyle

before the strip officially launched.

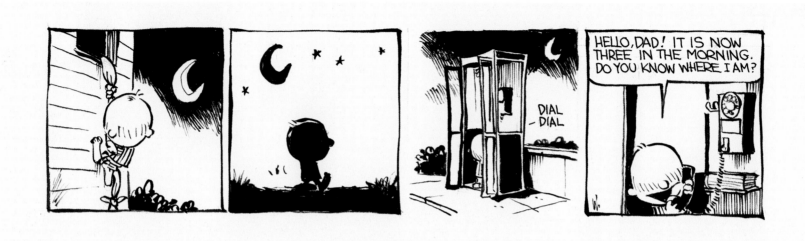

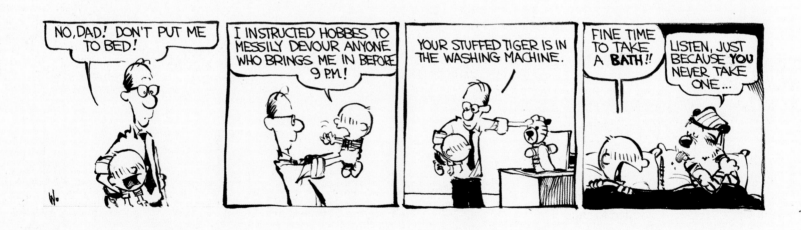

Calvin and Hobbes strips from syndicate submission, circa 1984

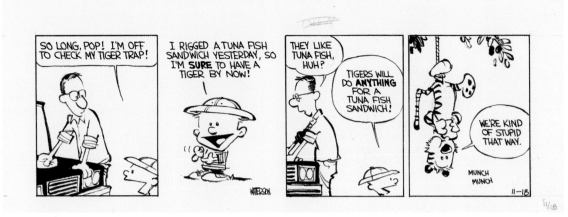

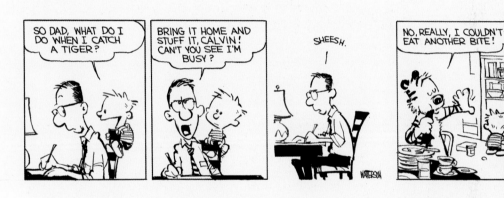

THE LAUNCH

Universal Press Syndicate launched *Calvin and Hobbes* in thirty-five newspapers in November 1985. Here are the first three dailies, which established the main premise of the strip. It quickly grew in popularity, and was appearing in 2,500 newspapers around the world when Watterson decided to end it in 1995.

All original *Calvin and Hobbes* strips in the exhibition are ink on paper. Some also include pencil and white-out.

First three dailies,
November 18-20, 1985

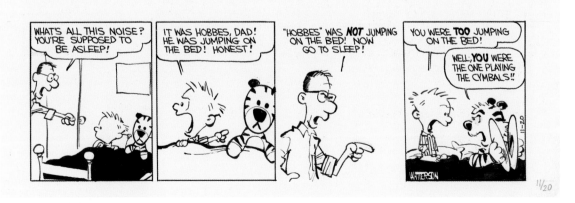

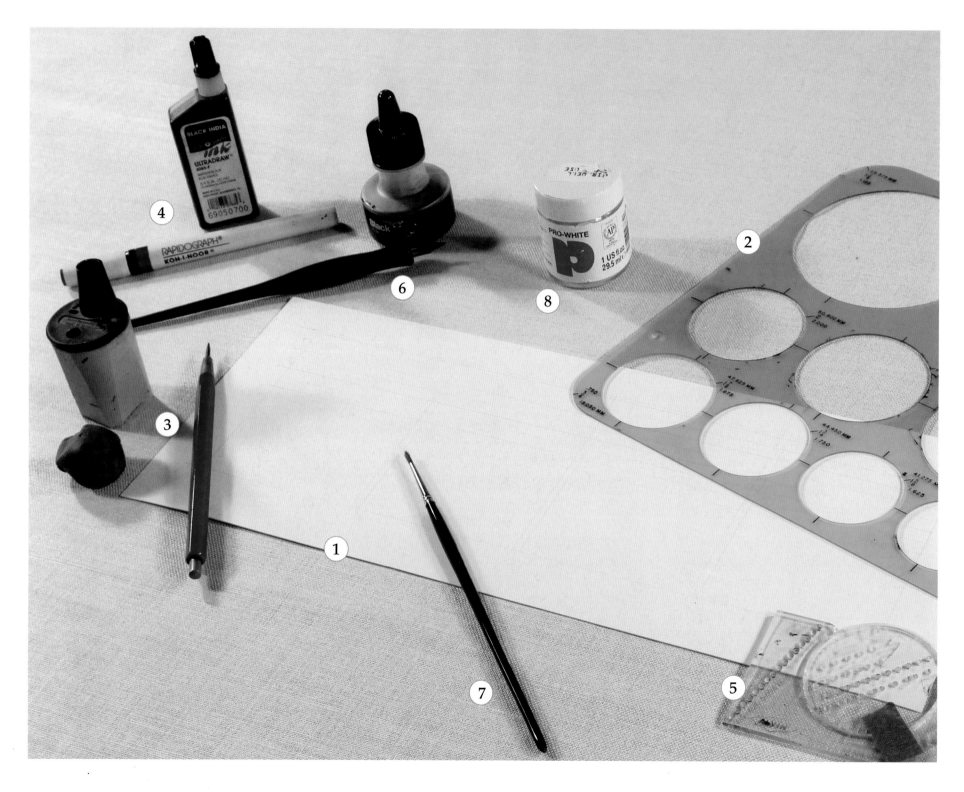

TOOLS

—Bill Watterson

AS EVERY serious artist knows, the difference between being a timeless genius and a hopeless amateur is the art supplies. Here are the tools I used:

1. STRATHMORE BRISTOL BOARD 3-PLY

The earliest strips were done on cheap, thin Bristol board, which sometimes did not take the ink well. Eventually I switched to this, which is pretty nice stuff. On an 11" x 14" sheet of paper, I would lay out two daily strips. That way, I could rule the panels for both strips at the same time without setting up a new sheet and remeasuring. Countless valuable minutes were saved this way.

2. CIRCLE TEMPLATE

In later years, I sometimes used this to draw round panels on my Sunday strips. The trick is to lift up the template without smearing the wet ink. (See "white-out.")

3. RED MECHANICAL PENCIL WITH 2H LEAD

Note the cool sharpener too. My dad got me this when I was a kid, and I've done all my cartoon penciling with it ever since.

4. RAPIDOGRAPH #2 WITH A .60 POINT, WHATEVER THAT MEANS

Technical pens provide the uniform, characterless line prized by aficionados of inexpressive drawing. I used it for panel outlines and for lettering.

5. CLEAR PLASTIC THING WITH HOLES

I don't even know what this is called. The idea is you stick your pencil in various holes and drag the gizmo along your T-square. This will give you evenly spaced, ruled lines for lettering. If you fuss with it and turn the little wheel, you can subdivide your lines for even greater lettering accuracy. I used that feature exactly zero times.

6. CROW QUILL PEN

If you want to know the finer considerations of pen nibs, ask Richard Thompson. I used any nib that would fit in the plastic holder. I used this pen to outline the word balloons and sign my name. Once in a while I'd do a little hatching with it.

7. SMALL SABLE BRUSH

I didn't mention the brush number, because no two brushes with the same number are the same size. But this is the one tool where you shouldn't skimp: a real sable brush holds a beautiful line.

8. WHITE-OUT

This covers up mistakes, but often the ink does not behave well when you go to draw over the white-out. In that case, the corrected drawing will need to be whited out too. Repeat until violent or until deadline elapses.

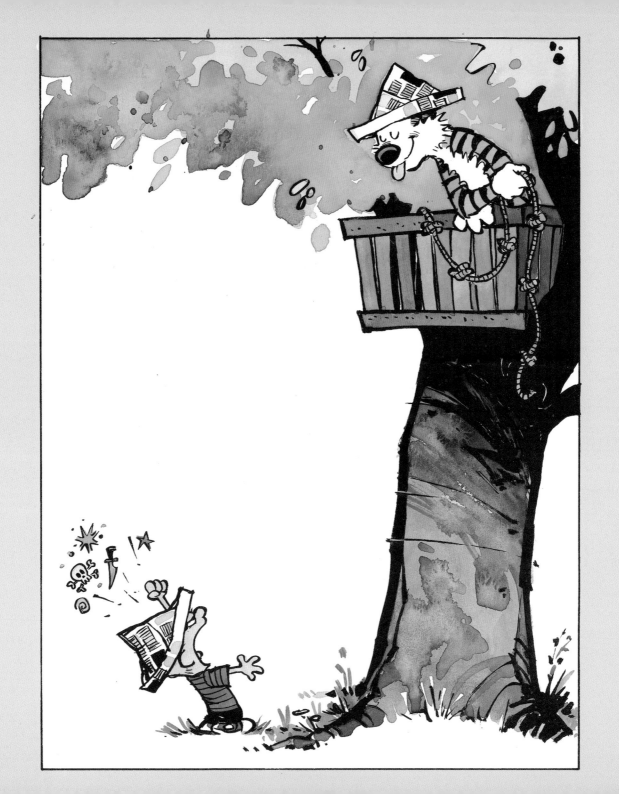

CHARACTERS

*"One of the reasons that Calvin is fun to write
is that I often don't agree with him."*

—Bill Watterson

CALVIN WAS named after John Calvin, the sixteenth-century theologian who

believed in predestination. Watterson's character Calvin was often devious, selfish,

and entitled, but he occasionally demonstrated a more vulnerable and

sweet side. He had a vivid imagination and thrived on driving his

parents and teachers crazy. Although he often spoke with sophistication

beyond his years, he remained six years old for the entire run of the strip.

CALVIN

July 30, 1988

September 1, 1988

August 26, 1992

April 6, 1993

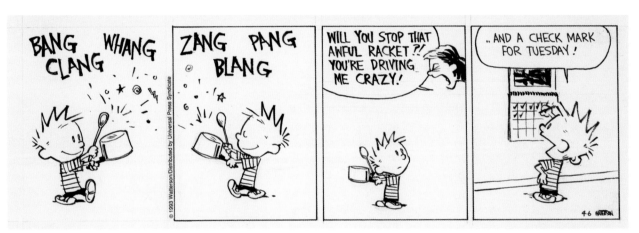

January 27, 1994

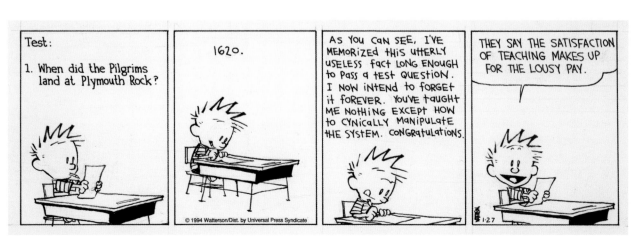

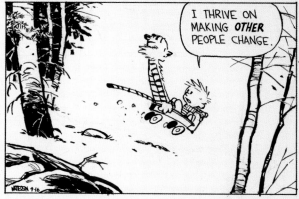

April 16, 1983

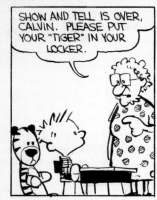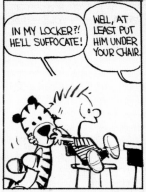

November 21, 1985

HOBBES

Hobbes was named after the seventeenth-century philosopher Thomas Hobbes. He appeared to most of the characters in the strip as a stuffed tiger, but Calvin saw him as a living, breathing animal who was part house cat and part wild tiger. Watterson's cat Sprite served as the model for Hobbes's physical appearance and personality.

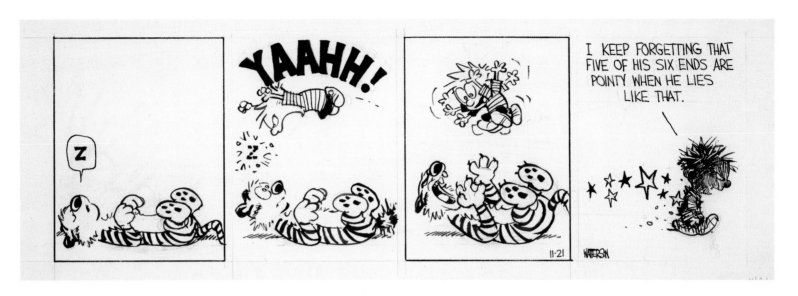

November 21, 1987

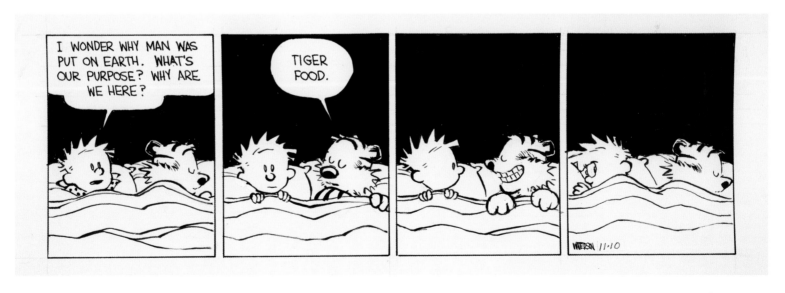

November 10, 1989

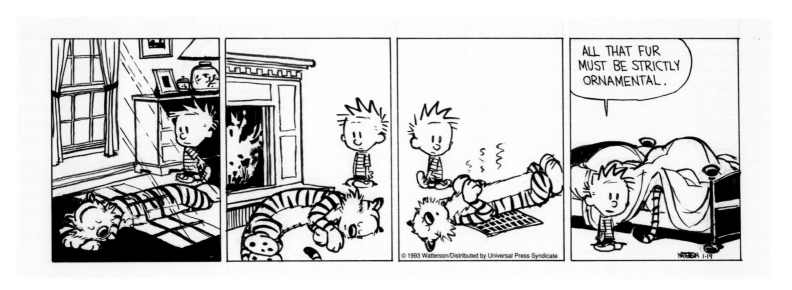

January 19, 1993

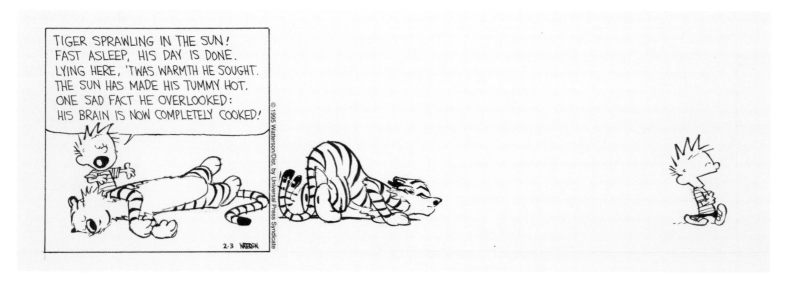

February 3, 1995

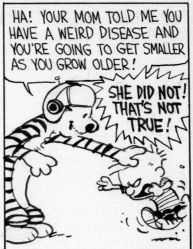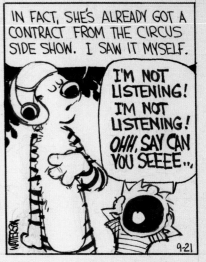

September 21, 1987

CALVIN AND HOBBES

Calvin's relationship with Hobbes was at the center of the strip. One moment they were best friends, playmates, and partners in crime; the next they fought like siblings. Hobbes frequently served as the voice of reason or as a wry commentator on Calvin's wild ideas and antics.

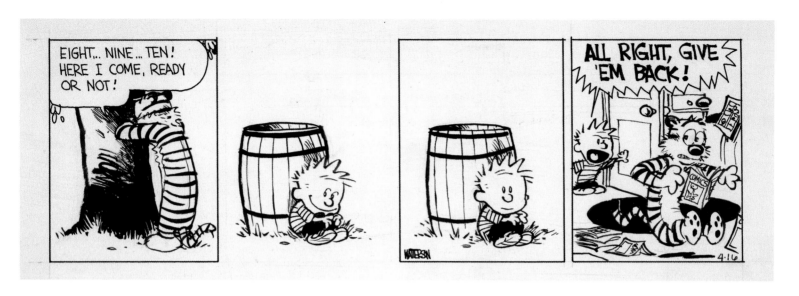

April 16, 1988

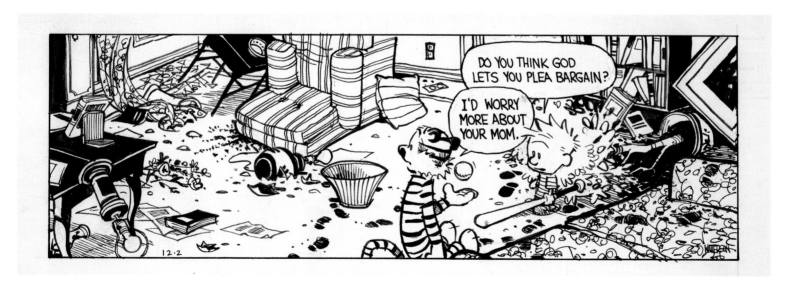

December 2, 1988

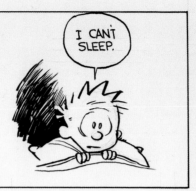

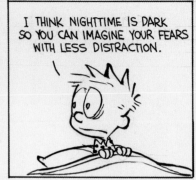

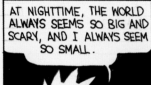

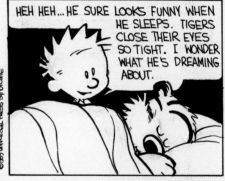

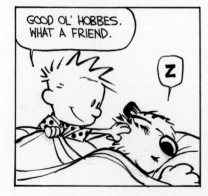

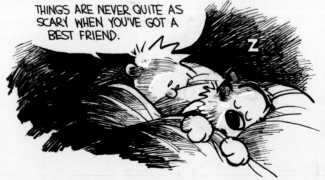

April 23, 1989

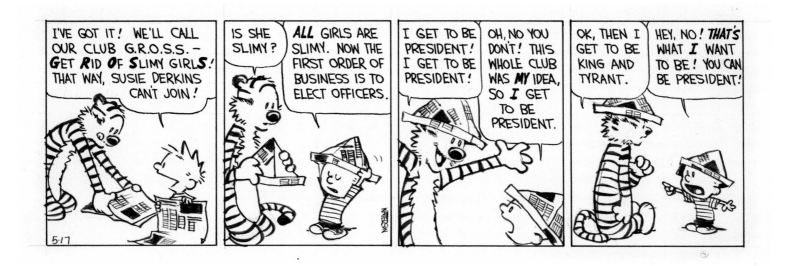

May 17, 1989

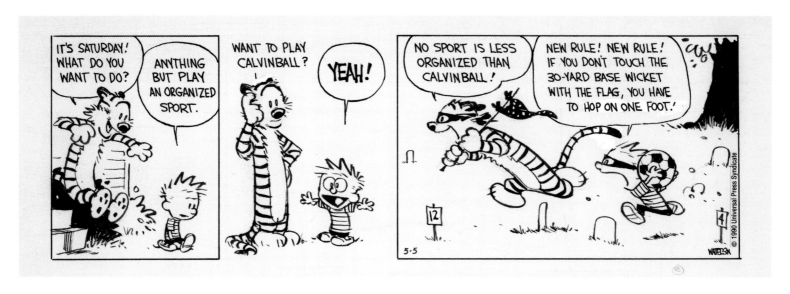

May 5, 1990

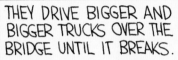

HOW DO THEY KNOW THE LOAD LIMIT ON BRIDGES, DAD?

LOAD LIMIT 10 TONS

THEY DRIVE BIGGER AND BIGGER TRUCKS OVER THE BRIDGE UNTIL IT BREAKS.

THEN THEY WEIGH THE LAST TRUCK AND REBUILD THE BRIDGE.

OH. I SHOULD'VE GUESSED.

DEAR, IF YOU DON'T KNOW THE ANSWER, JUST TELL HIM!

11-26

November 26, 1986

CALVIN'S PARENTS

Calvin's dad was partly autobiographical and partly based on Watterson's own father. He worked as a patent attorney (just like Watterson's dad). He's generally optimistic, frequently exasperated, and always willing to lecture Calvin on building character.

Calvin's mom had her hands full trying to keep him out of mischief. She was the disciplinarian and didn't let him get away with much, but she also had a softer side.

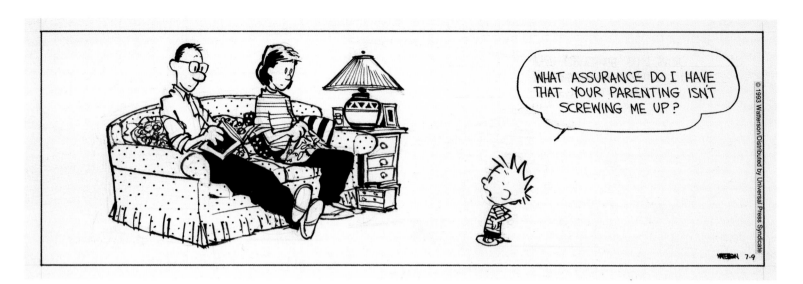

July 9, 1993

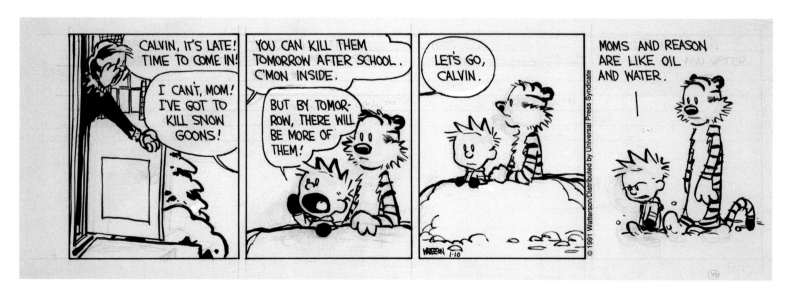

January 10, 1991

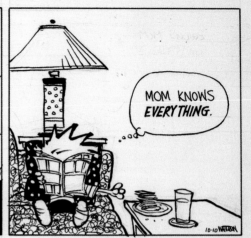

October 10, 1992

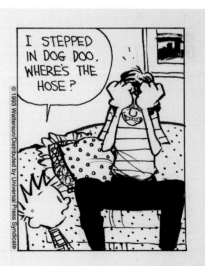

July 21, 1993

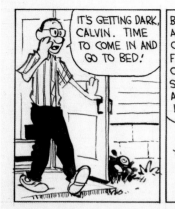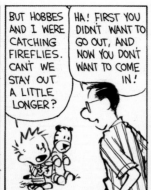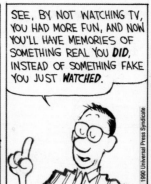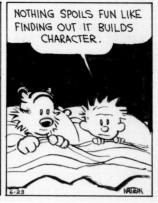

June 23, 1990

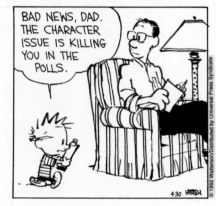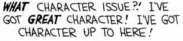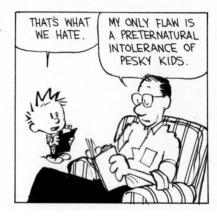

April 30, 1992

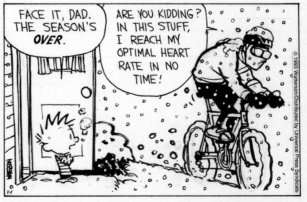

January 1, 1993

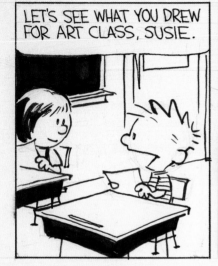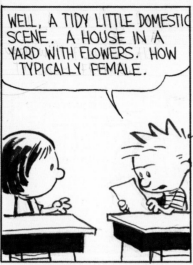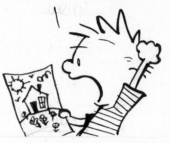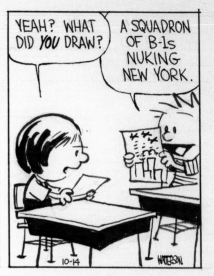

October 14, 1987

SUPPORTING CAST

Calvin and Hobbes featured a relatively small cast of characters, including Calvin's neighbor and classmate Susie, his babysitter Rosalyn, the school bully Moe, and his teacher Mrs. Wormwood.

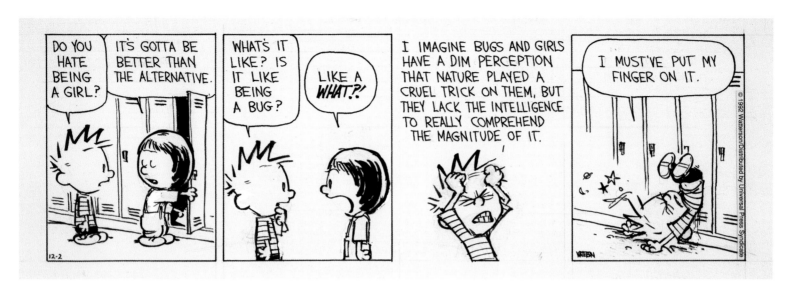

December 2, 1992

January 18, 1994

September 5, 1995

October 29, 1990

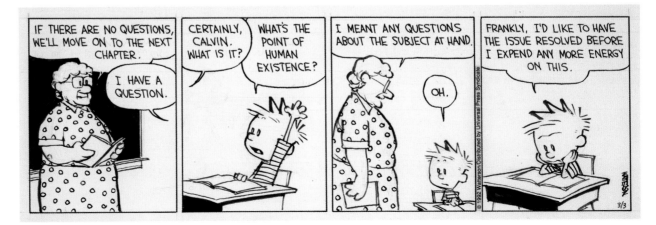

March 3, 1992

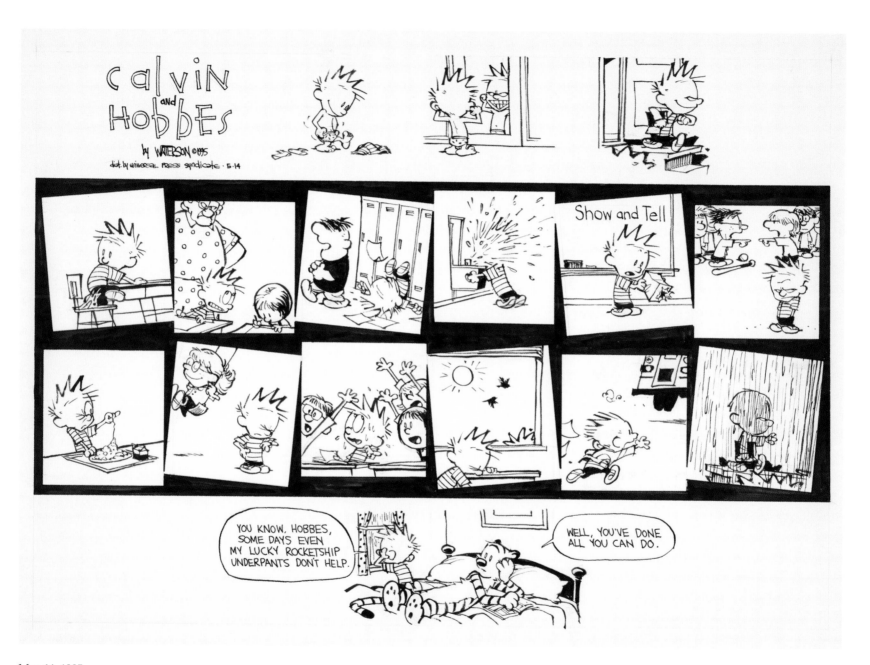

May 14, 1995

SEASONS

THE RHYTHM of the seasons is an important element in *Calvin and Hobbes*.

Watterson lived in the Southwest for most of the time he drew the strip, but it

takes place in the climate of northern Ohio, where he grew up. The four distinct

seasons provided Watterson with many recurring devices and themes that set

the stage for each day's action.

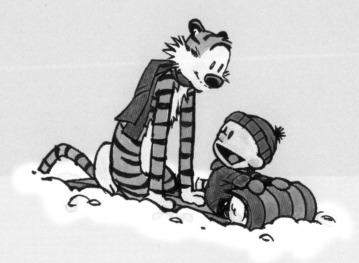

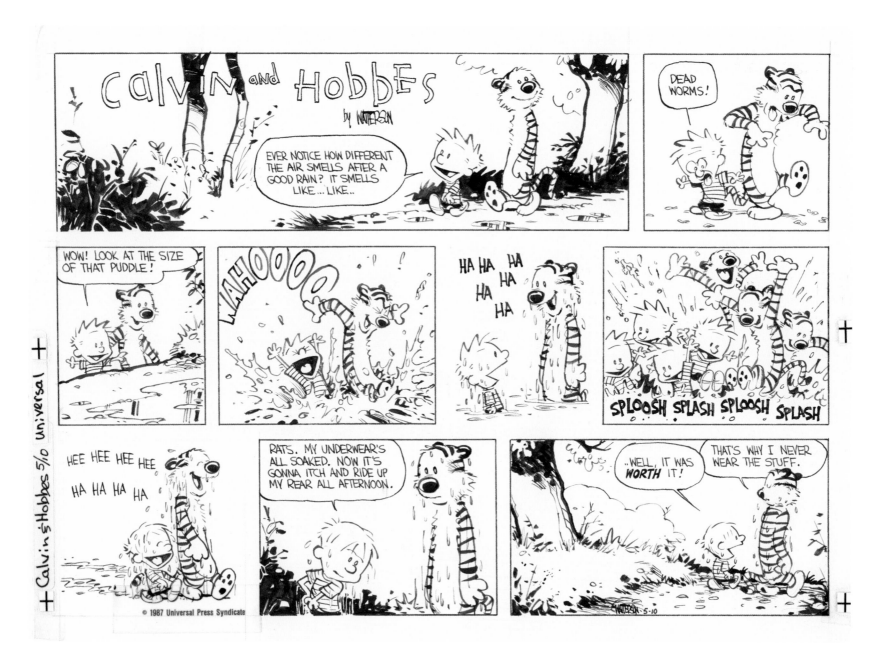

May 10, 1987

April 12, 1989

SPRING

Spring brought rain, mud puddles, and eventually the end of the school year,
which for Calvin could never come soon enough.

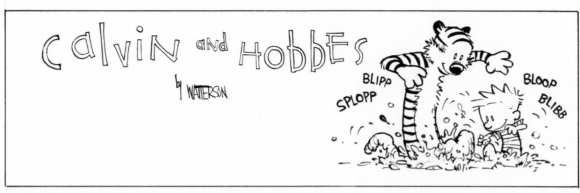
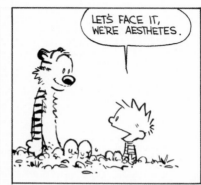
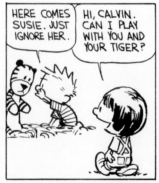
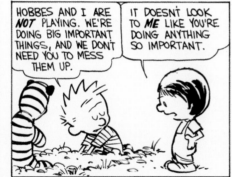
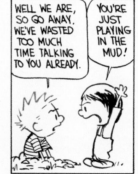
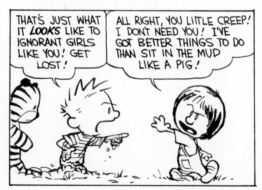
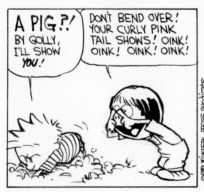
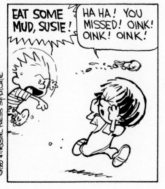

May 21, 1989

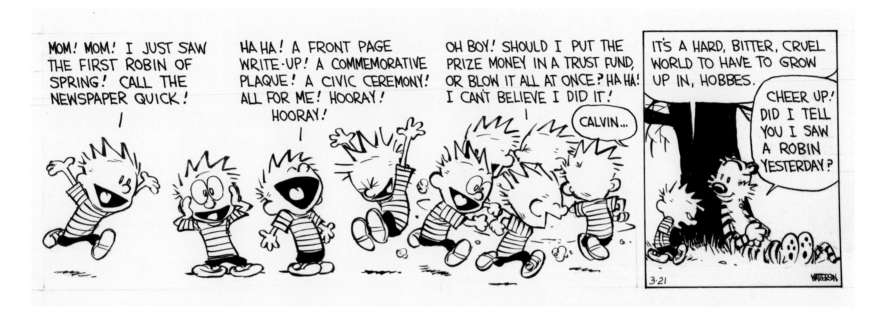

March 21, 1990

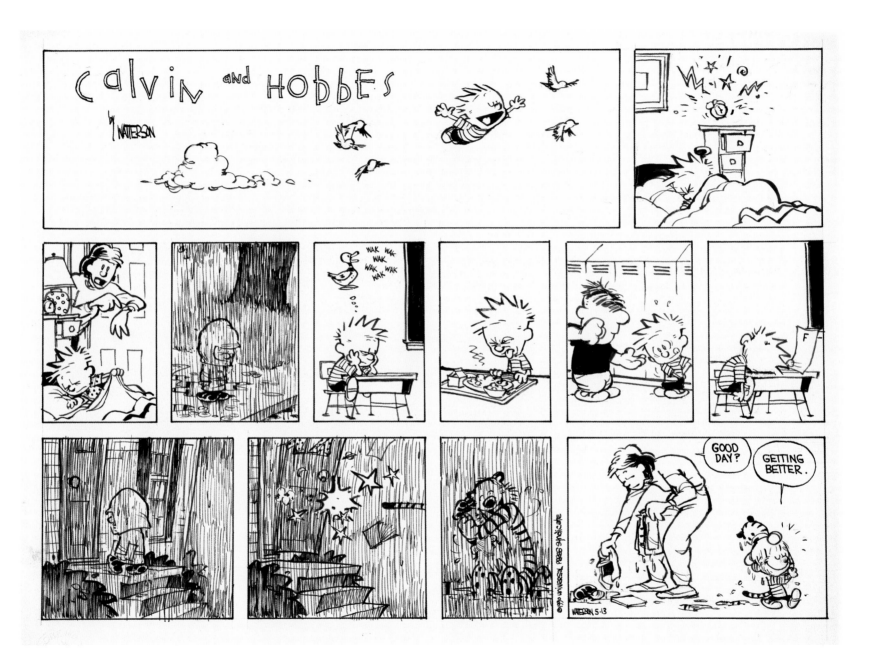

May 13, 1990

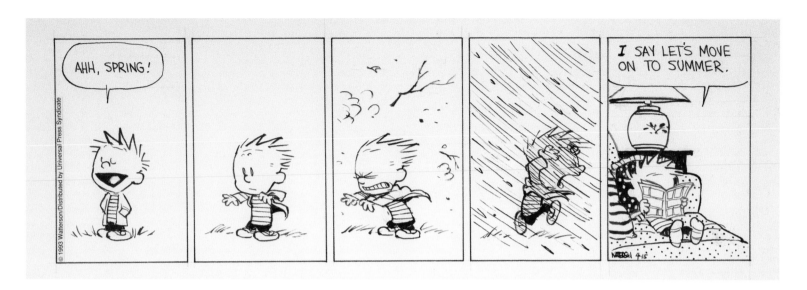

April 15, 1993

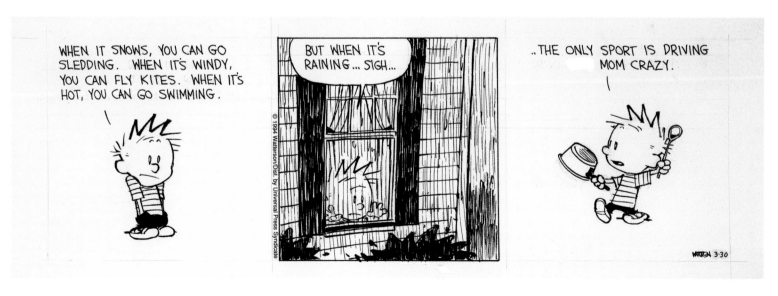

March 30, 1994

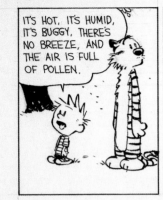
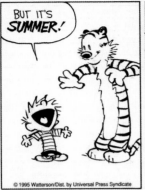
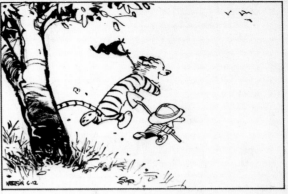

June 12, 1995

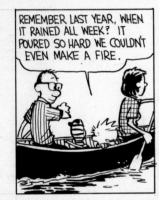
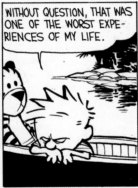
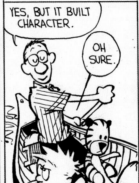
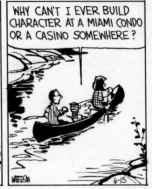

June 15, 1988

SUMMER

Summer consisted of endless days of exploring, wagon rides, playing Calvinball,
or just doing nothing, although it also meant the dreaded family camping trip.

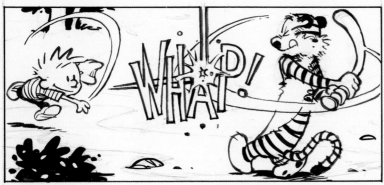
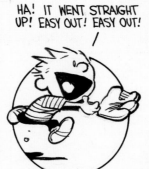
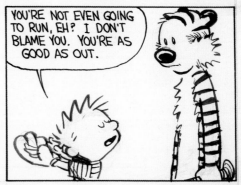
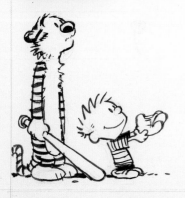
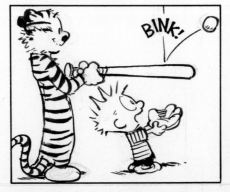
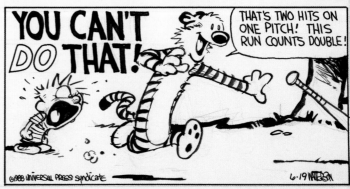

June 19, 1988

July 24, 1989

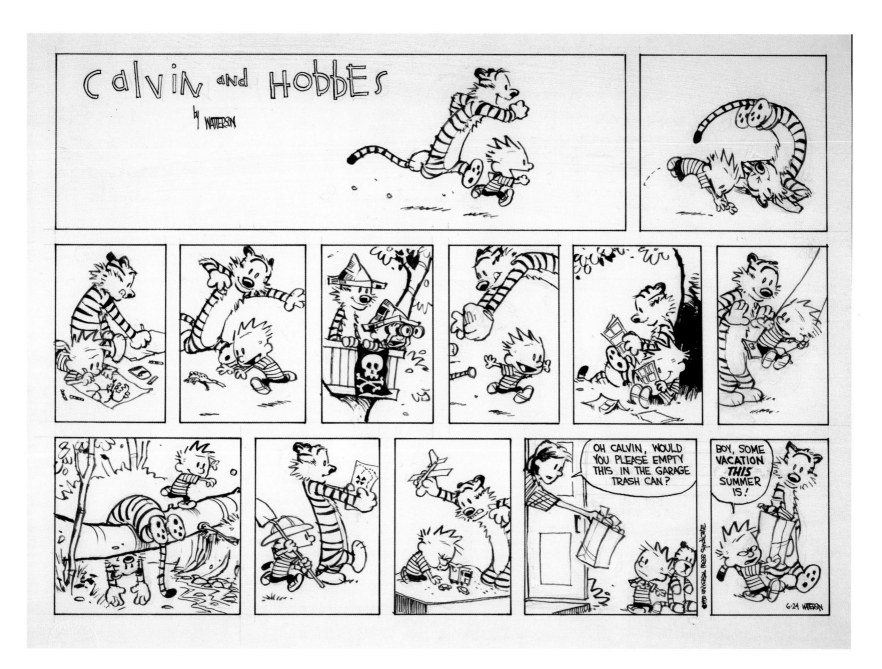

June 24, 1990

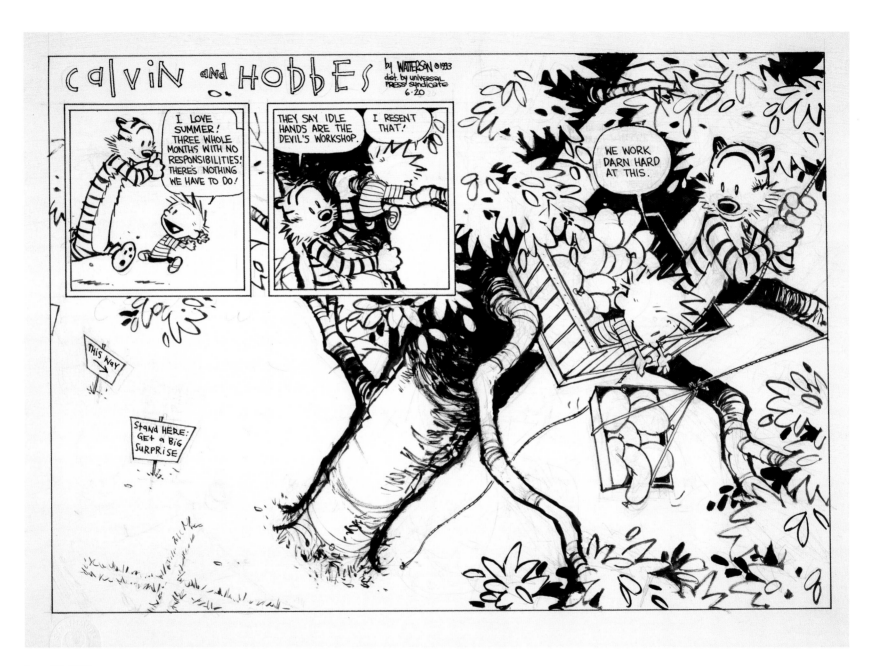

June 20, 1993

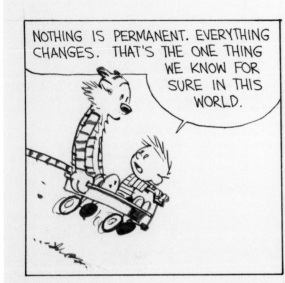

July 17, 1995

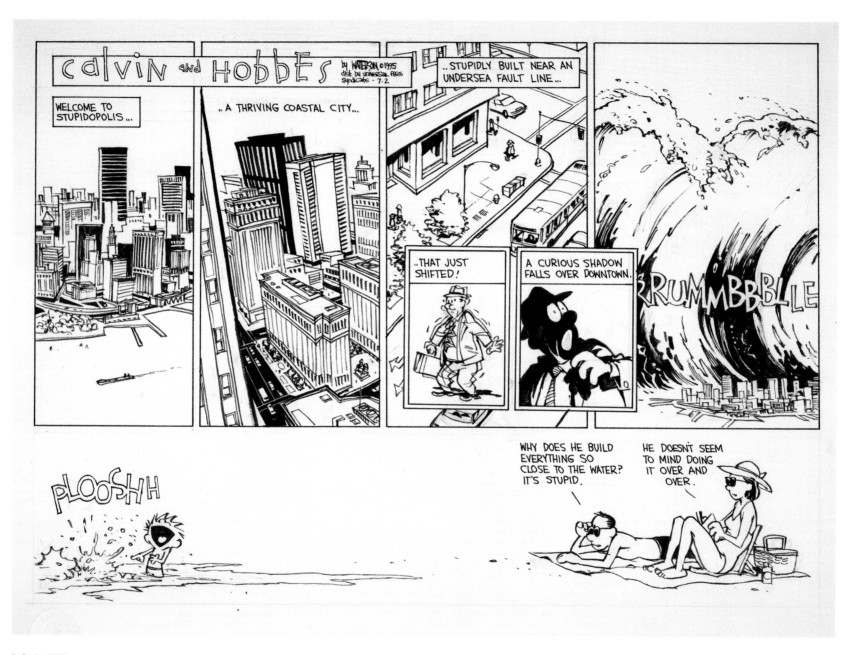

July 2, 1995

August 21, 1995

August 24, 1987

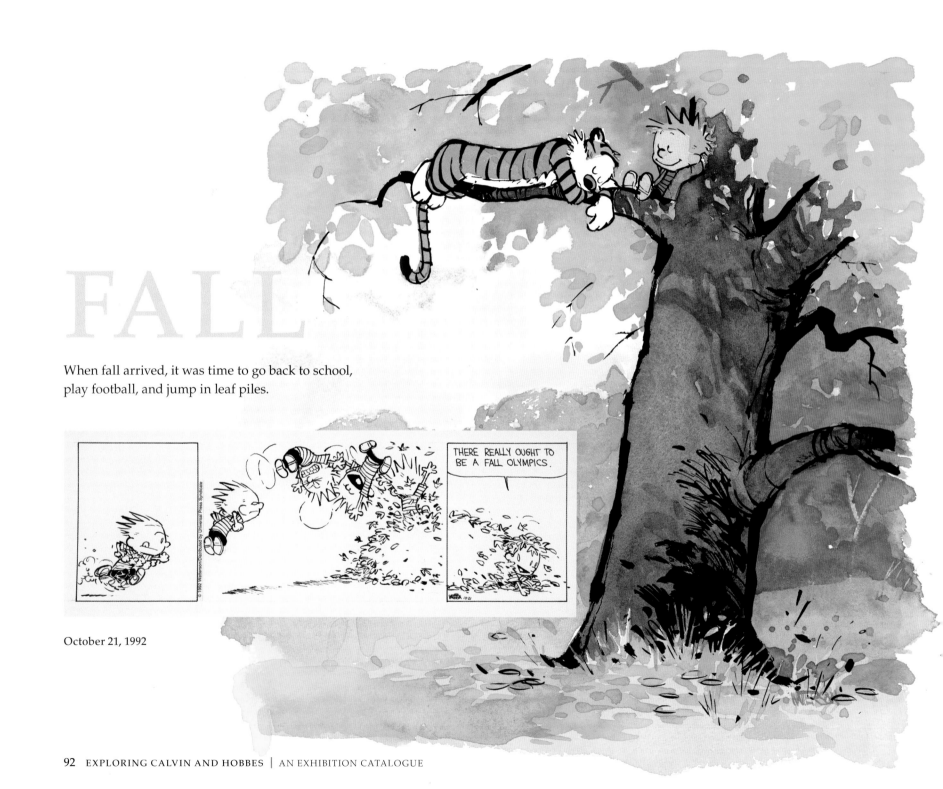

FALL

When fall arrived, it was time to go back to school,
play football, and jump in leaf piles.

THERE REALLY OUGHT TO
BE A FALL OLYMPICS.

October 21, 1992

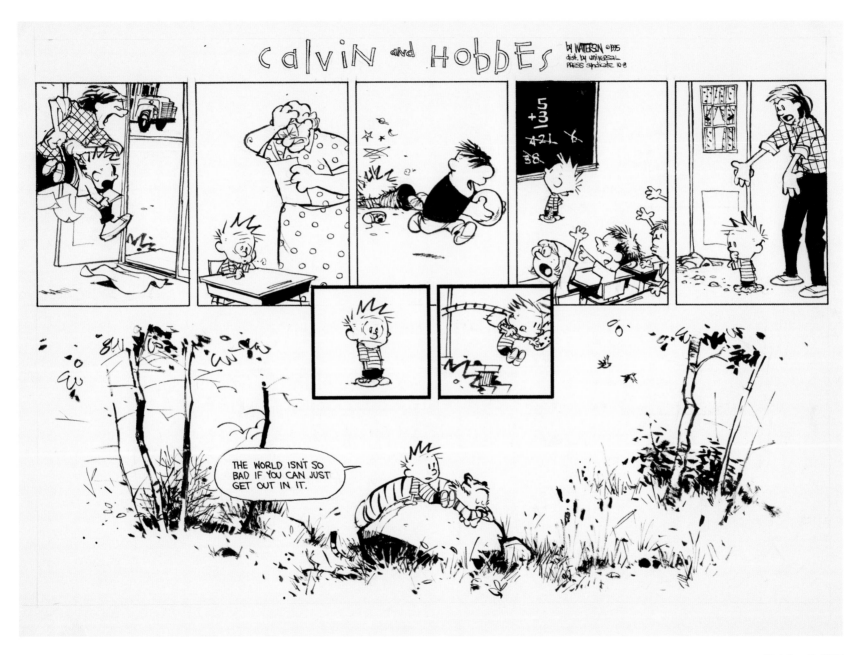

October 8, 1995

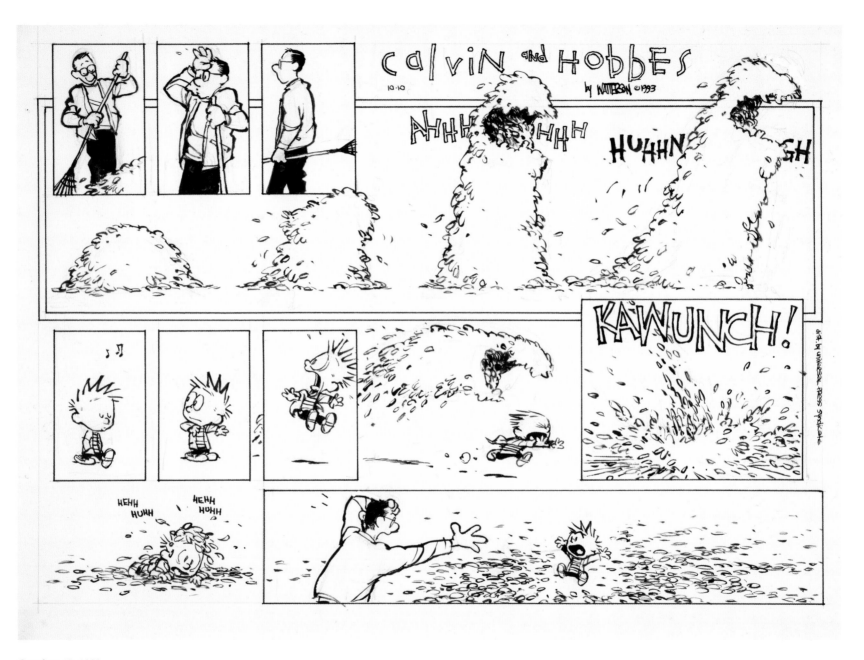

October 10, 1993

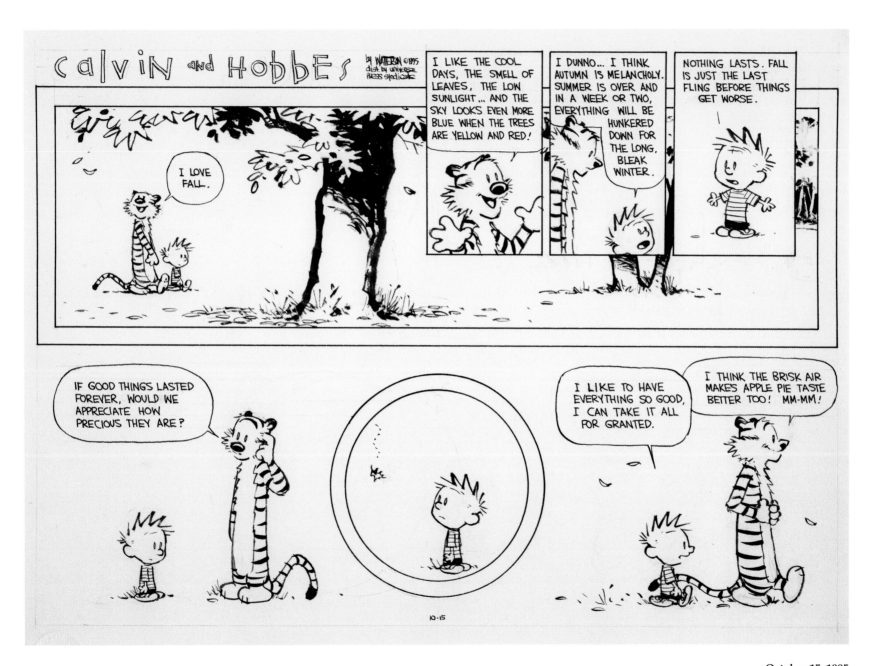

October 15, 1995

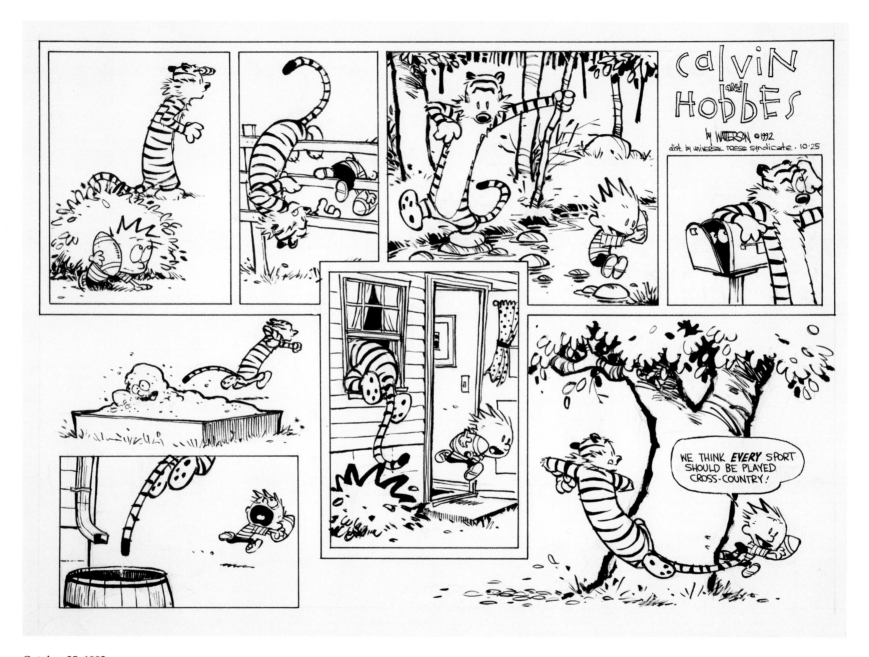

October 25, 1992

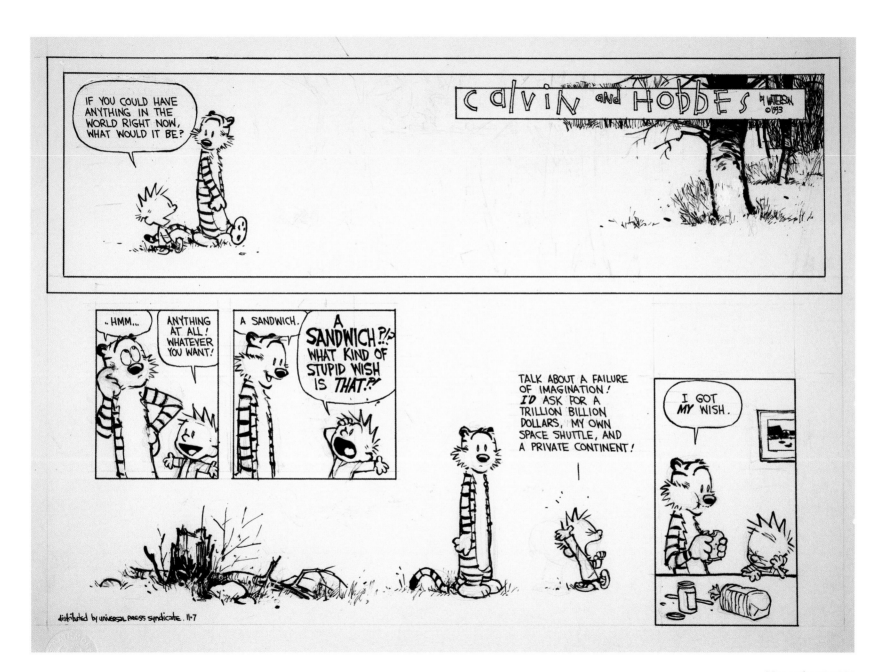

November 7, 1993

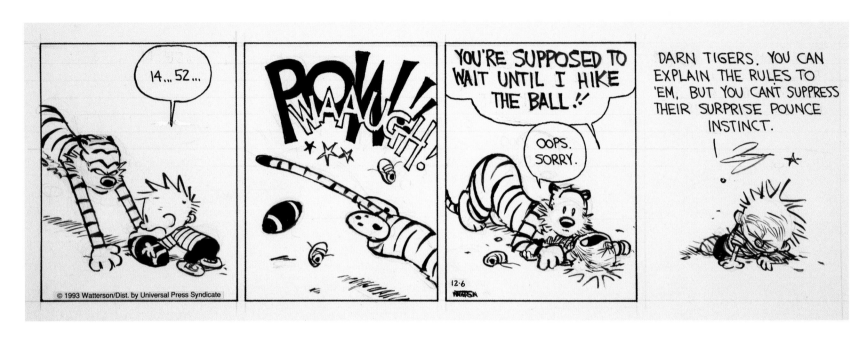

December 6, 1993

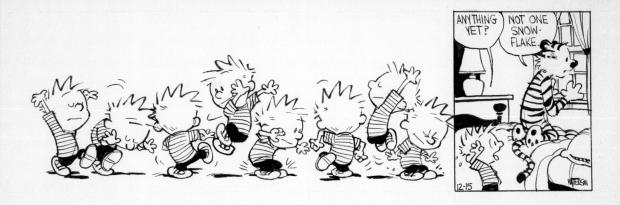

December 15, 1987

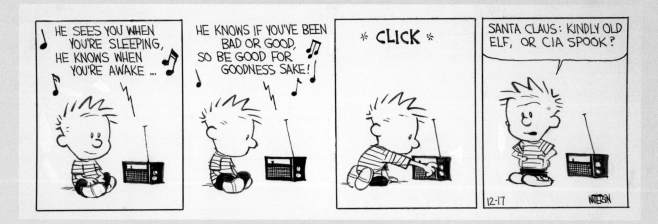

December 17, 1987

WINTER

Winter featured plentiful snow for making snowballs and building grotesque snowmen, Calvin's doomed efforts to be good before Christmas, and sled rides over snow-covered hills that provided the perfect backdrop for talking about the meaning of life.

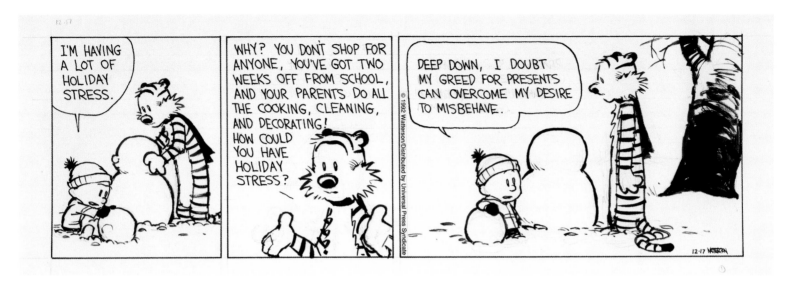

December 17, 1992

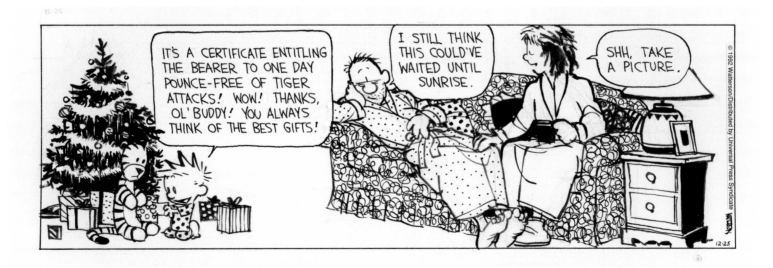

December 25, 1992

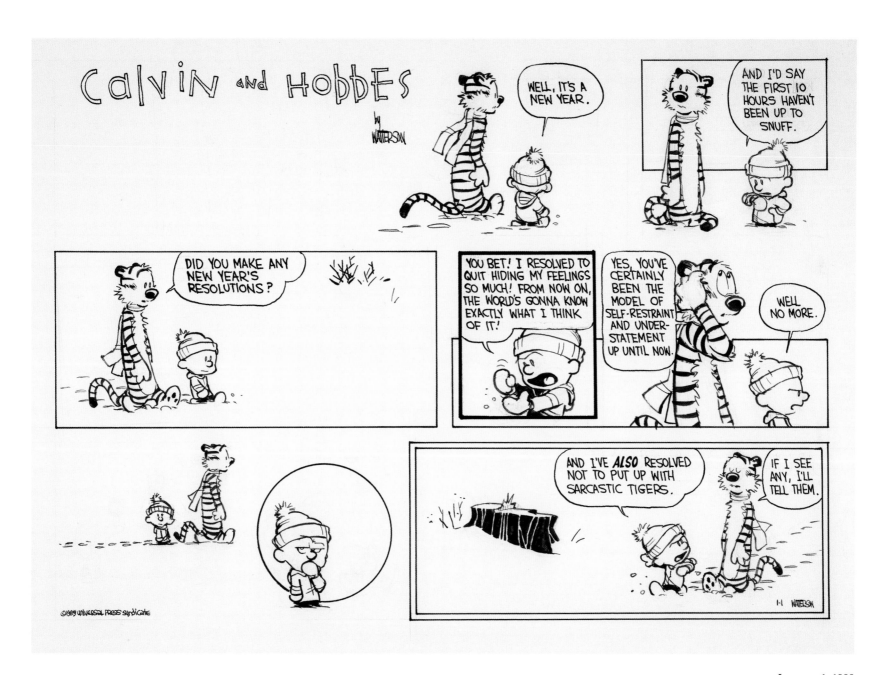

January 1, 1989

January 7, 1989

January 22, 1989

January 24, 1989

February 17, 1991

January 18, 1993

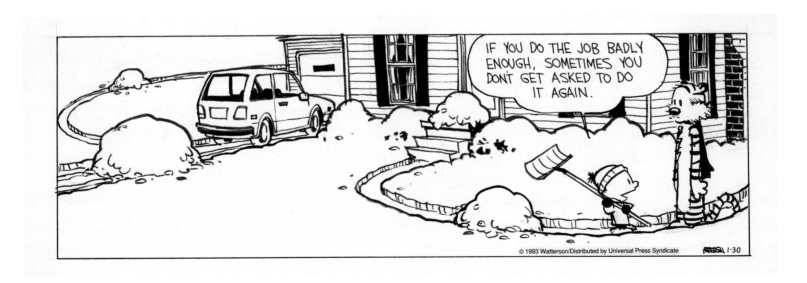

January 30, 1993

DEVICES

"A cartoonist is someone who has to draw the same thing day after day without repeating himself."

—Charles Schulz

COMING UP with new and original ideas for 365 strips per year is a

daunting task. Comic strip creators often use recurring devices, or variations

on a single idea or theme. These devices become an inside joke the cartoonist

and the reader share.

May 29, 1987

ATTACK OF THE TIGER

Watterson excelled at inventing new versions of his devices, especially Hobbes's habit of attacking Calvin. Although the mood could strike at any time, Hobbes particularly loved to pounce when Calvin arrived home from school. In one creative variation, the joke revolved around the fact that Hobbes didn't attack, which only regular readers of the strip would have fully understood.

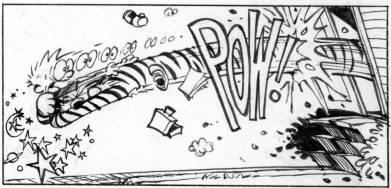

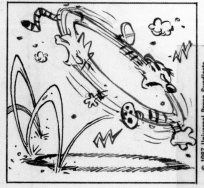

© 1987 Universal Press Syndicate

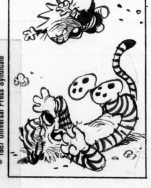

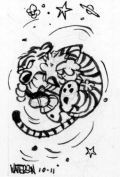

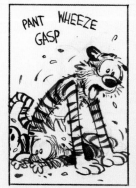

PANT WHEEZE GASP

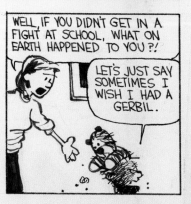

WELL, IF YOU DIDN'T GET IN A FIGHT AT SCHOOL, WHAT ON EARTH HAPPENED TO YOU?!

LET'S JUST SAY SOMETIMES I WISH I HAD A GERBIL.

October 11, 1987

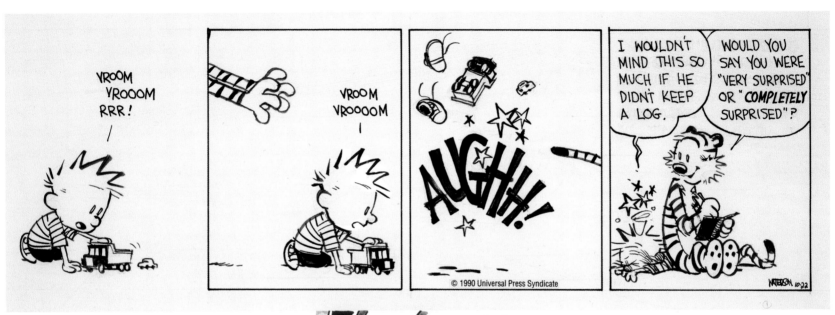

October 22, 1990

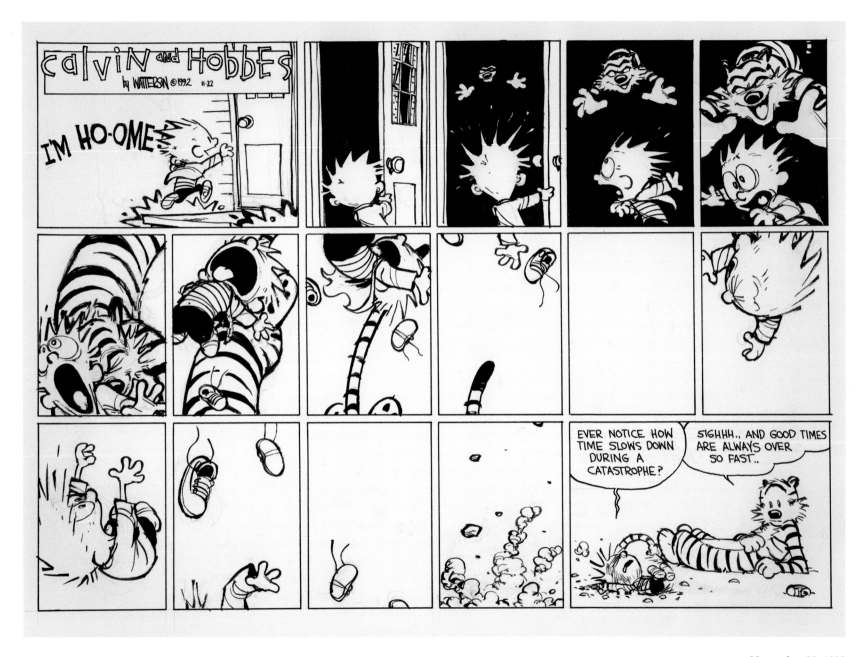

November 22, 1992

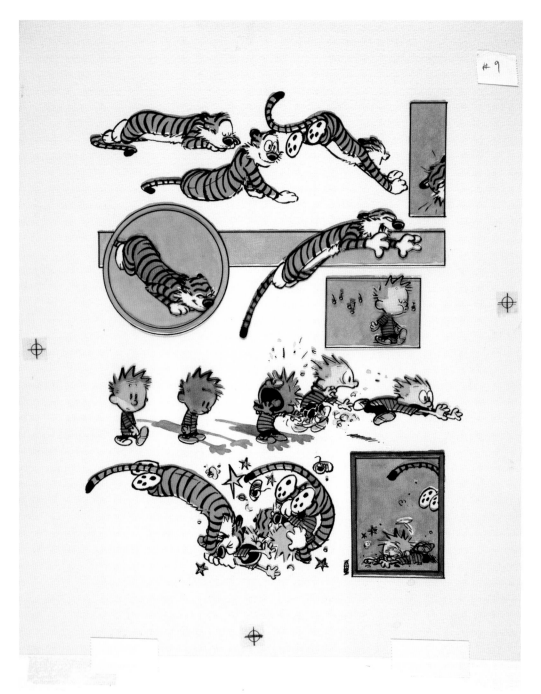

Back cover: *The Authoritative Calvin and Hobbes*, 1990, watercolor with black line drawing printed on acetate overlay

SPACEMAN SPIFF

Another popular device featured Calvin as fearless explorer Spaceman Spiff. An early version of Spiff, called *Raumfahrer Rolf*, first appeared in a comic Watterson created for a high school German class assignment. Watterson revived him in various forms over the years, including making Spiff the star of the first comic strip he submitted to the syndicates, which was rejected. Finally, Watterson brought Spiff back again to serve as one of Calvin's favorite alter egos, first appearing in the second week of the strip.

As the strip developed, Watterson drew Calvin's fantasy world in an increasingly realistic style. The contrast added a unique and visually engaging dimension to the strip.

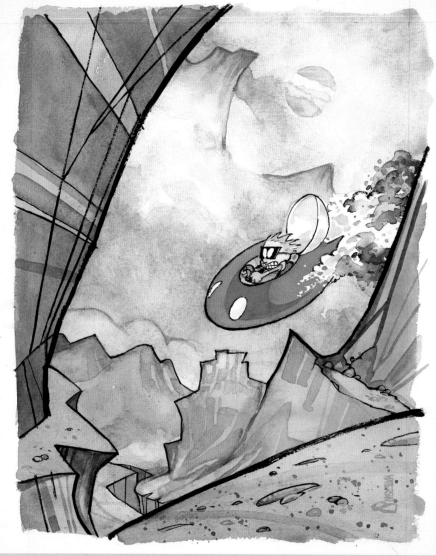

Spaceman Spiff watercolor,
circa 1987, watercolor on paper

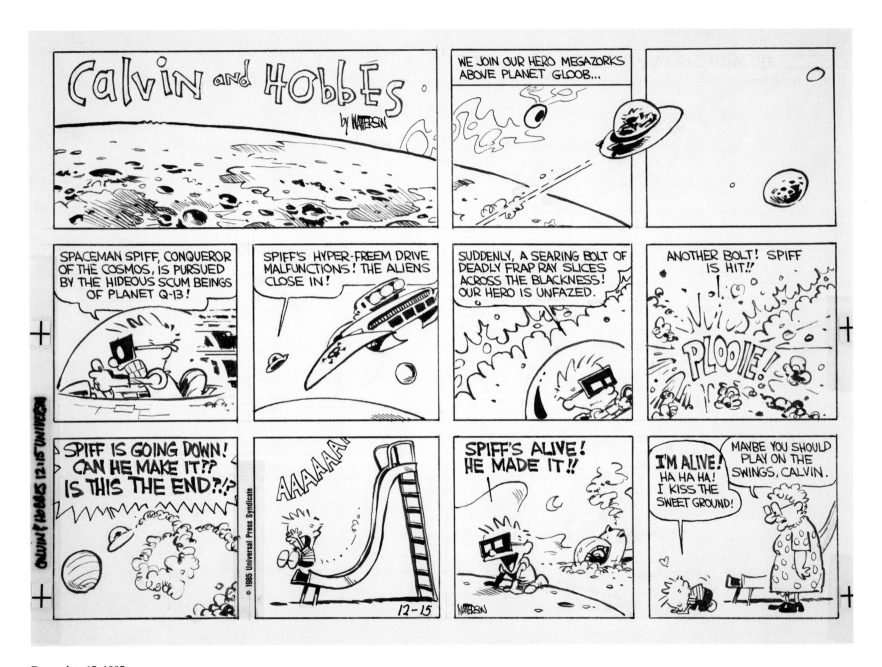

December 15, 1985

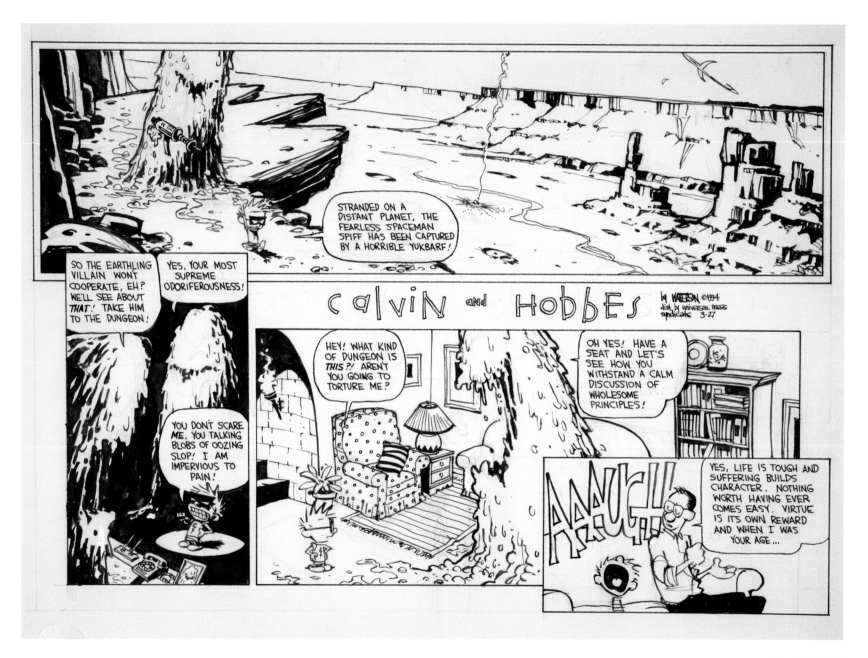

March 27, 1994

Photo by Bill Watterson, Monument Valley Navajo Tribal Park, Utah, 1995

Photo by Bill Watterson, Canyonlands National Park, Utah, 1993

SOUTHWESTERN LANDSCAPES

The backgrounds of the alien planets Spiff visited and the worlds Calvin's imagination conjured up increasingly came to reflect the southwestern landscapes that Watterson experienced while living and traveling in the region.

The first photograph above was taken when Watterson visited Monument Valley to see the area that had inspired *Krazy Kat*'s creator, George Herriman. The second photograph shows the canyon landscapes in Utah that Watterson fell in love with and used for his Spaceman Spiff strips.

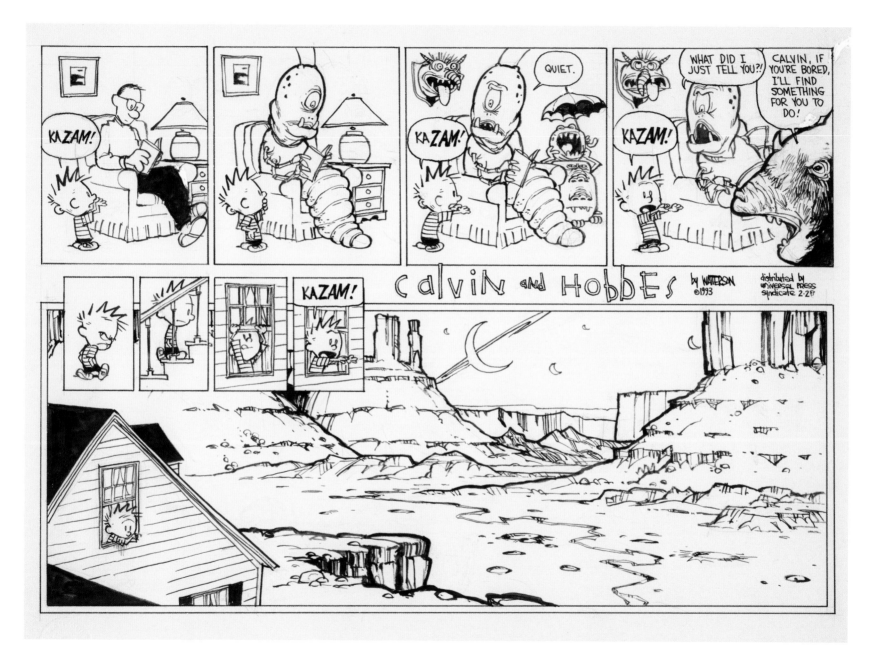

February 28, 1993

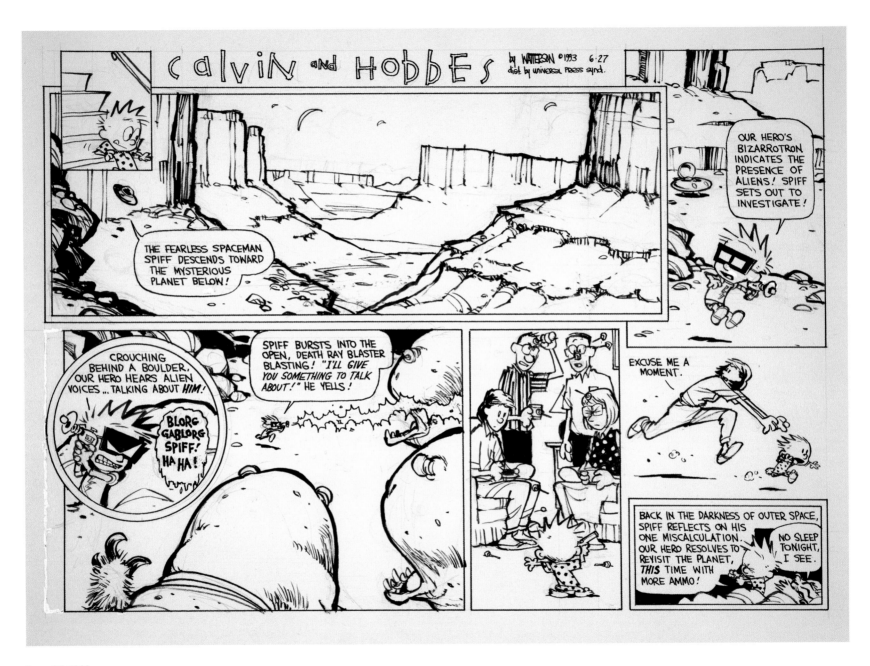

June 27, 1993

Painting of southwestern landscape, 1995, plein air oil sketch

Painting of southwestern landscape, 1995, plein air oil sketch

DINOSAURS

"For Calvin, dinosaurs are very, very real."

—Bill Watterson

Calvin often imagined himself as a dinosaur. The huge, monstrous reptiles are everything a six-year-old boy is not, but often wishes he could be. As an artist, Watterson reveled in learning about these creatures and depicting them in a realistic way.

Back cover, *The Calvin and Hobbes Lazy Sunday Book*, 1989, oil on board

October 31, 1993

July 9, 1995

STORYTELLING

WATTERSON FREQUENTLY used the daily strips to tell longer stories that
lasted up to three weeks. This story introduced Calvin's "transmogrifier" that
could turn him into anything at all. The same cardboard box later served as a
time machine and a "duplicator."

MARCH 23–APRIL 3, 1987

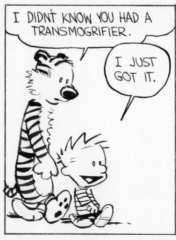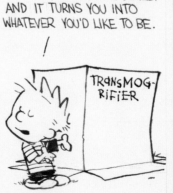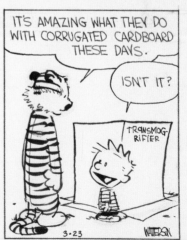

March 23, 1987

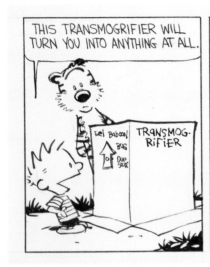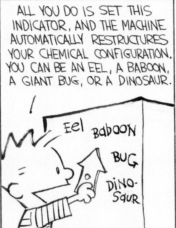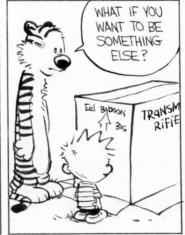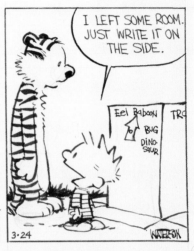

March 24, 1987

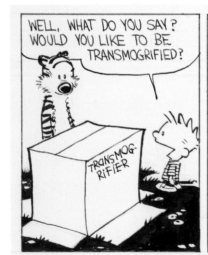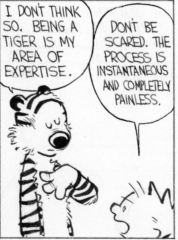

March 25, 1987

March 26, 1987

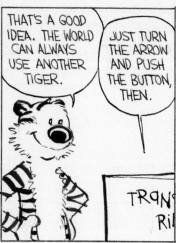
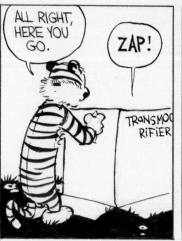
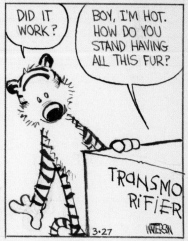

March 27, 1987

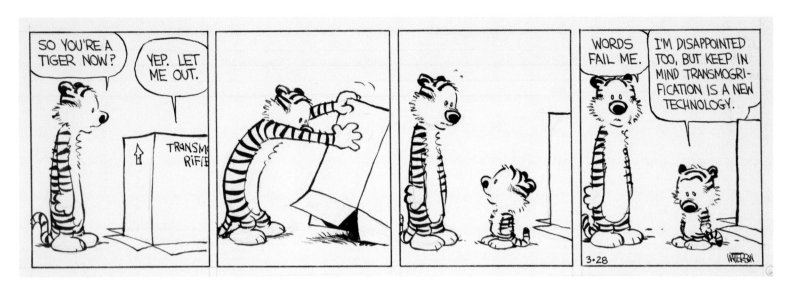

March 28, 1987

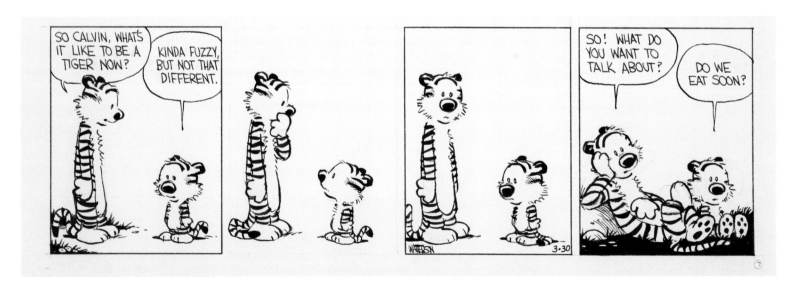

March 30, 1987

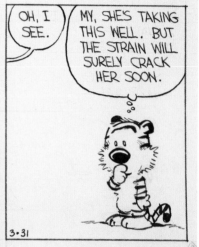

March 31, 1987

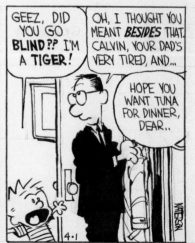

April 1, 1987

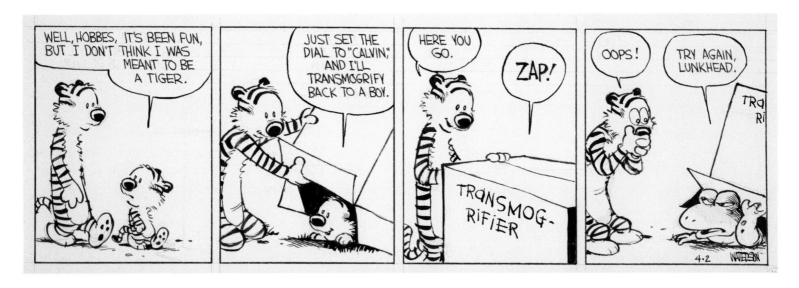

April 2, 1987

April 3, 1987

SOCIAL COMMENTARY

WATTERSON USED the strip to discuss topical issues that interested or

concerned him, including the environment, media, art, and popular culture.

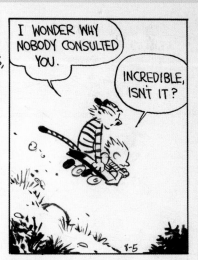

August 5, 1989

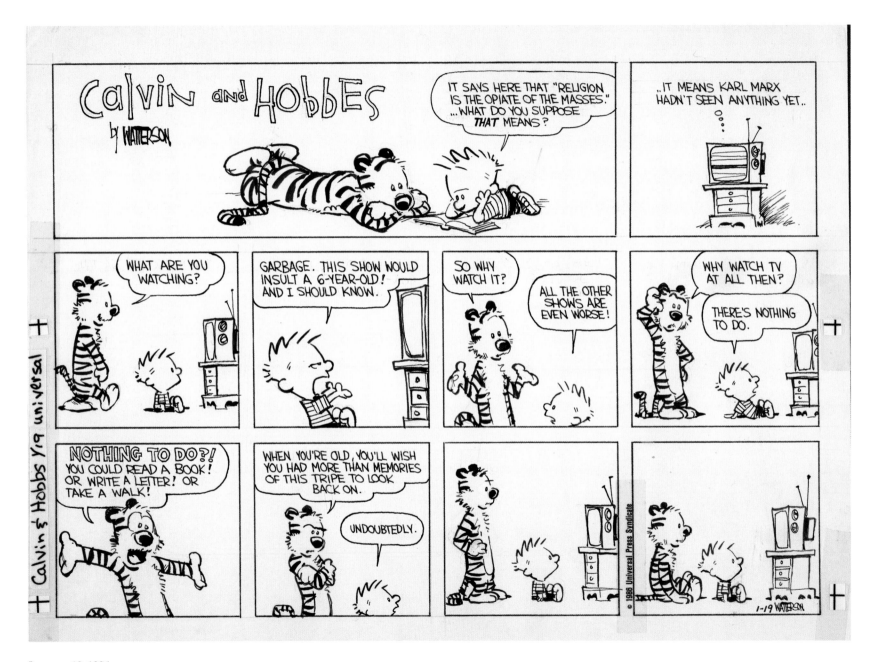

January 19, 1986

I WAS READING ABOUT HOW COUNTLESS SPECIES ARE BEING PUSHED TOWARD EXTINCTION BY MAN'S DESTRUCTION OF FORESTS.

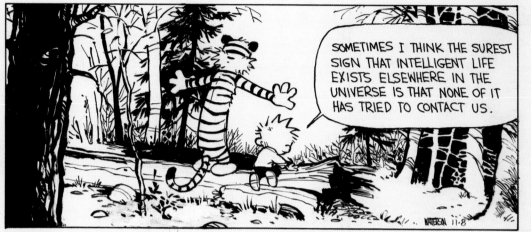
SOMETIMES I THINK THE SUREST SIGN THAT INTELLIGENT LIFE EXISTS ELSEWHERE IN THE UNIVERSE IS THAT NONE OF IT HAS TRIED TO CONTACT US.

November 8, 1989

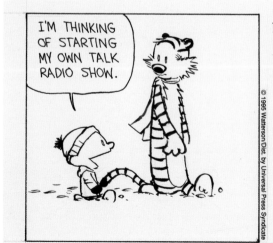
I'M THINKING OF STARTING MY OWN TALK RADIO SHOW.

© 1995 Watterson/Dist. by Universal Press Syndicate

I'LL SPOUT SIMPLISTIC OPINIONS FOR HOURS ON END, RIDICULE ANYONE WHO DISAGREES WITH ME, AND GENERALLY FOSTER DIVISIVENESS, CYNICISM, AND A LOWER LEVEL OF PUBLIC DIALOG!

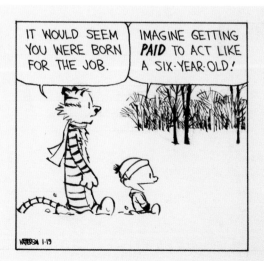
IT WOULD SEEM YOU WERE BORN FOR THE JOB.

IMAGINE GETTING *PAID* TO ACT LIKE A SIX-YEAR-OLD!

January 19, 1995

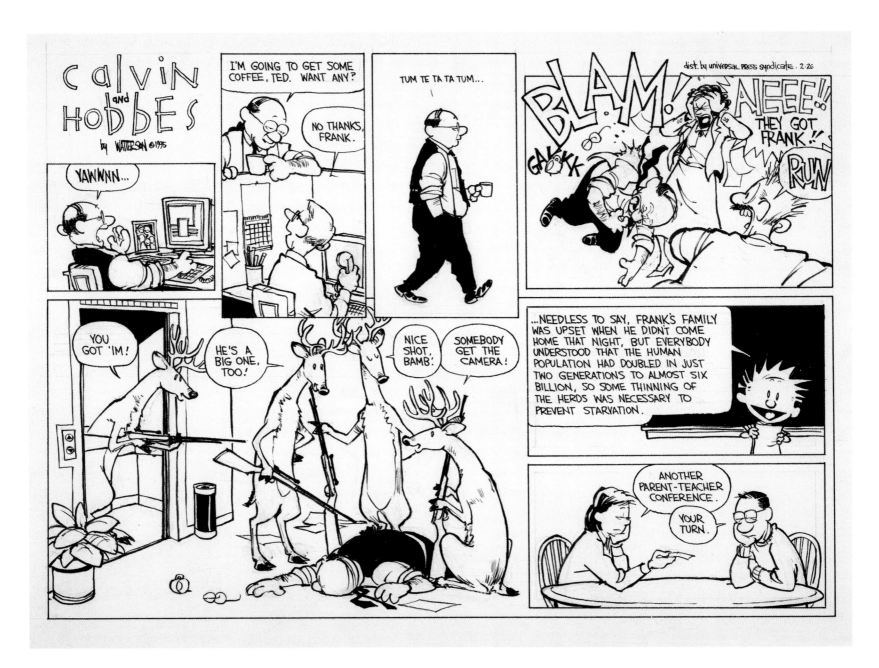

February 26, 1995

THE MEANING OF LIFE

CALVIN OFTEN pondered the nature of human existence

and the meaning of life.

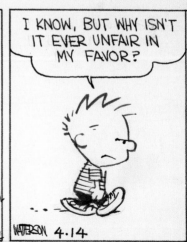

April 14, 1986

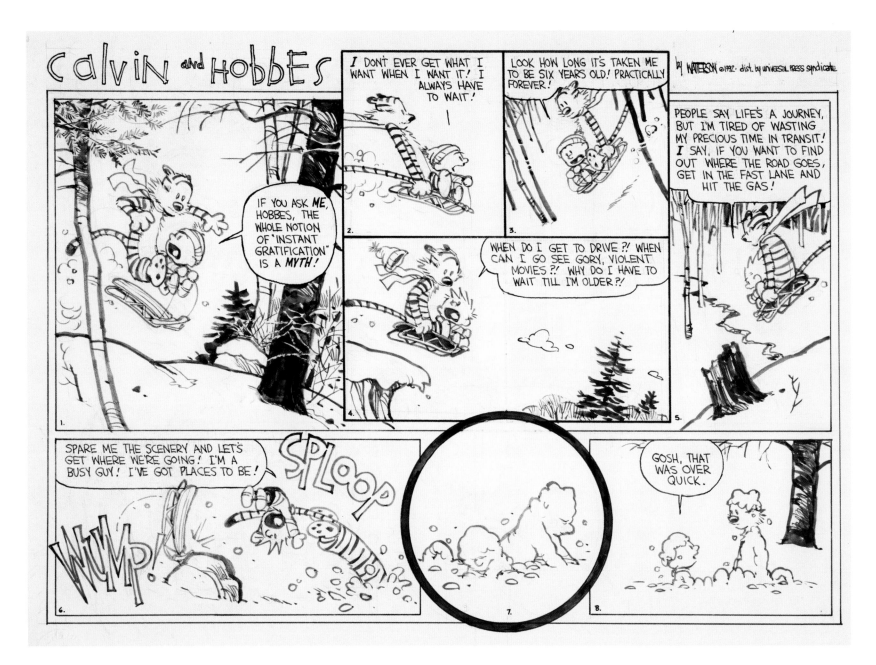

February 2, 1992

April 9, 1988

July 8, 1988

August 25, 1993

December 11, 1993

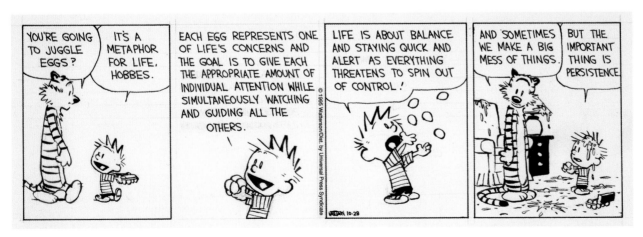

October 28, 1995

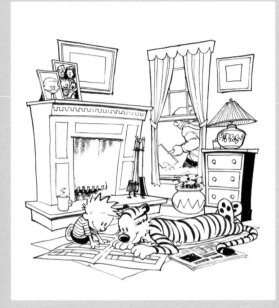

COLOR

WATTERSON CREATED these painted works for

the *Calvin and Hobbes* book collections.

He used a variety of methods to

achieve a satisfactory result in print,

including using acetate overlays

for the black line on some while

fully painting others. He also

experimented with different

color palettes to evoke different

seasons or moods.

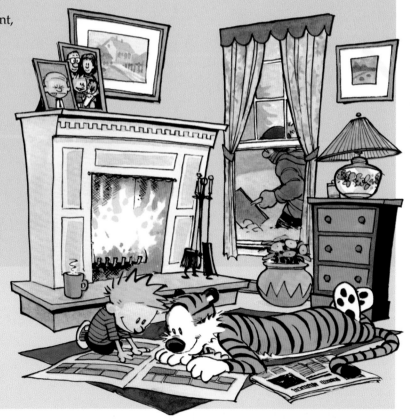

Cover of *The Calvin and Hobbes Lazy Sunday Book*, two
pieces, 1989, ink on paper/watercolor on paper

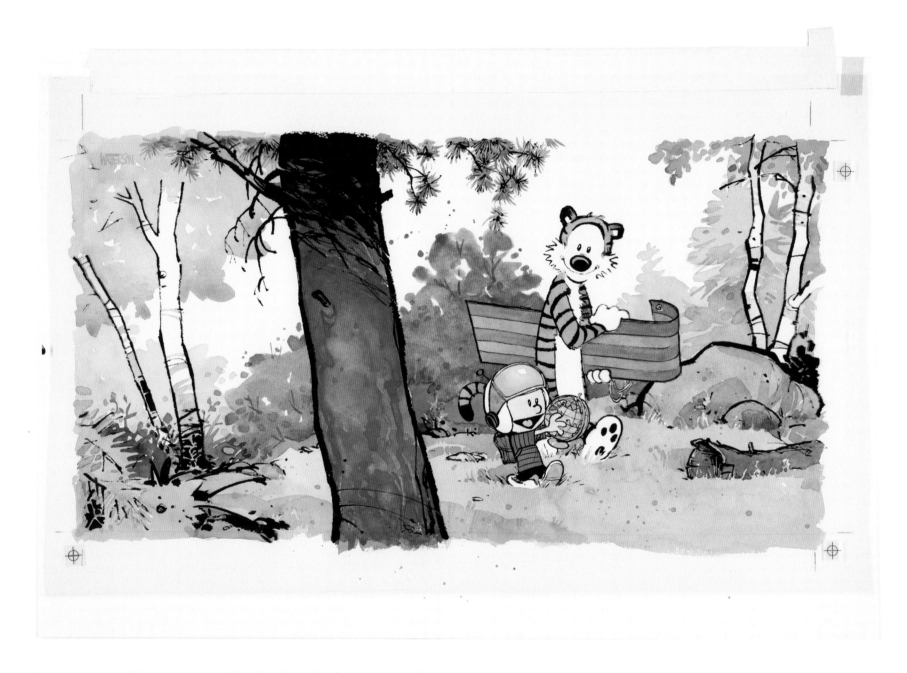

Cover of *Yukon Ho!* 1989, watercolor with line drawing printed on acetate overlay

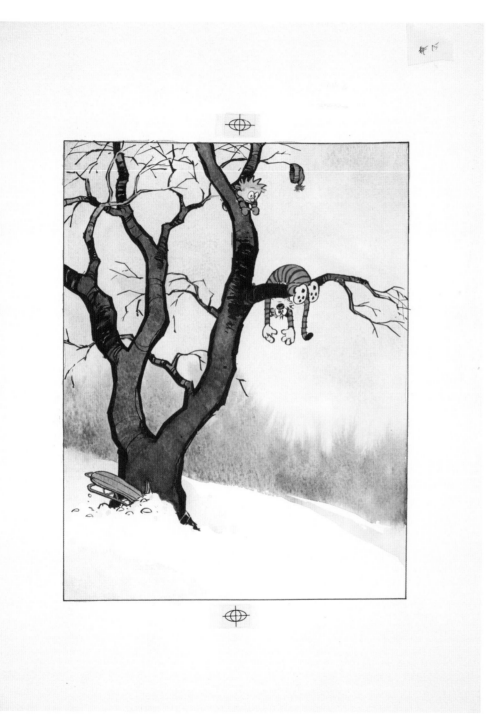

Title page of *The Authoritative Calvin and Hobbes*, 1990, watercolor on paper

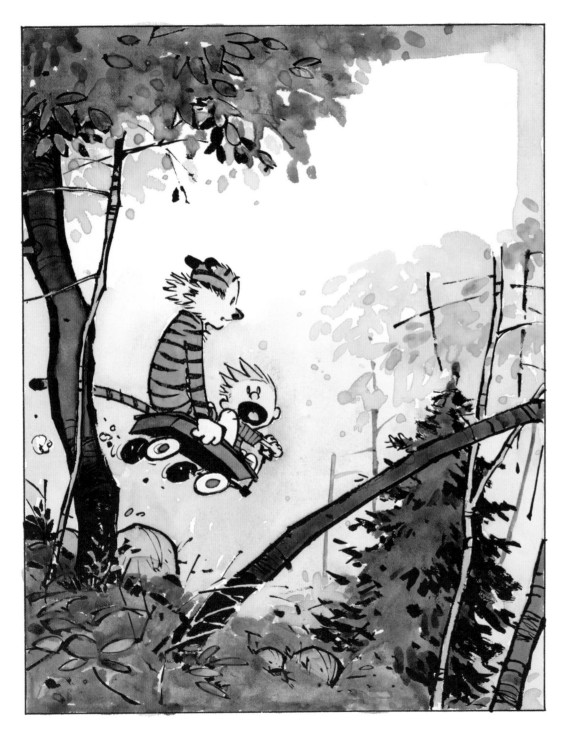

Title page of *The Indispensable Calvin and Hobbes*, 1992, watercolor on paper

SUNDAYS

TO DRAW a comic strip is to create with constraints.

The number, length, and width of the panels are dictated by the newspaper editors, who developed a system that would give them the maximum flexibility to fit as many strips as possible onto a single page.

In Watterson's early Sundays, he kept the panels the same size, but soon he began to use more creative layouts, pushing to their limits the constraints the newspapers imposed.

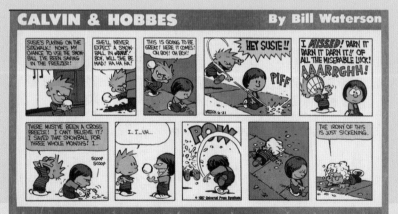

TOP: half page Sunday strip layout diagram, showing mandatory panel divisions

MIDDLE: same panels rearranged in two rows and reduced, in order to run as a quarter of a page

BOTTOM: first row removed ("throwaway" joke), to run as a third of a page

1985–1991

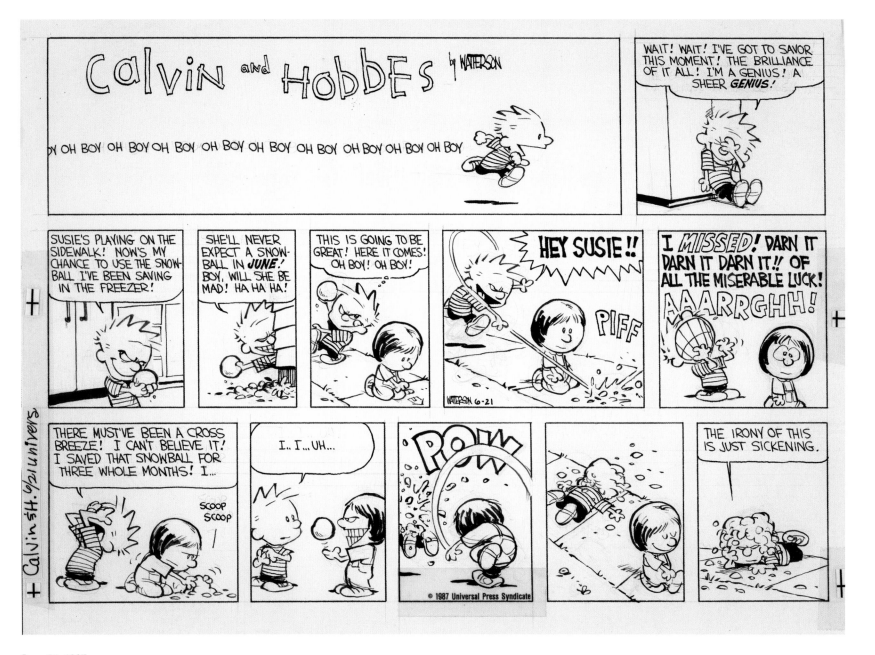

June 21, 1987

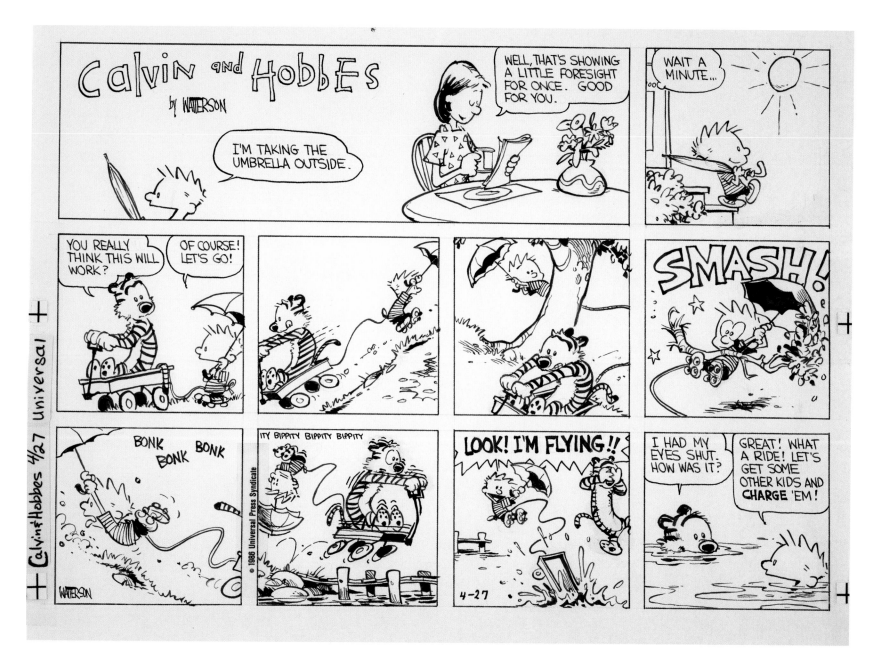

April 27, 1986

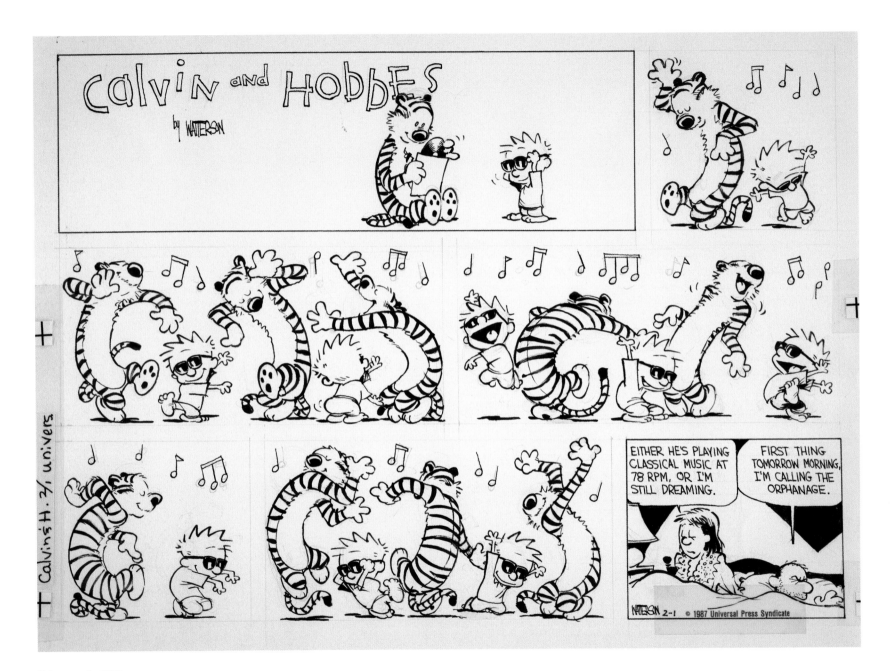

February 1, 1987

1992–1995

*"The last few years of the strip, and especially the Sundays,
are the work I am the most proud of. This was as close as
I could get to my vision of what a comic strip should be."*

—Bill Watterson

Watterson became increasingly frustrated with the limitations the standard Sunday comic strip format imposed. He envied the freedom enjoyed by early comic strip artists like George Herriman to design their strips exactly how they wanted them to appear in print. During his sabbatical from May 1991 through January 1992, Watterson proposed changing the format of his Sunday strips so that he could arrange the layouts to match that week's concept, rather than trying to fit the idea into the panels the industry prescribed. His syndicate agreed to try it when he returned. Although some newspaper editors grumbled about the new approach, the results took the strip to a new level.

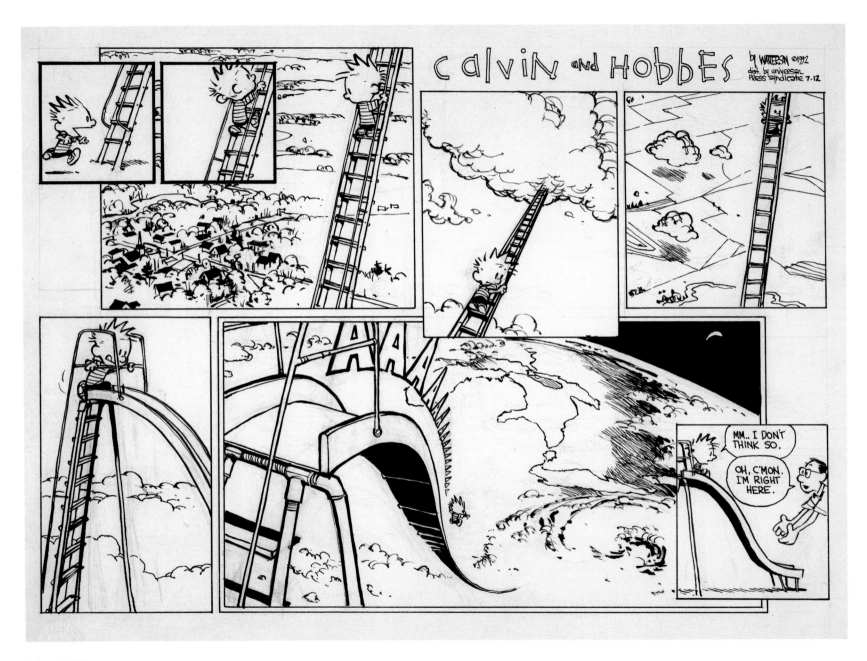

July 12, 1992

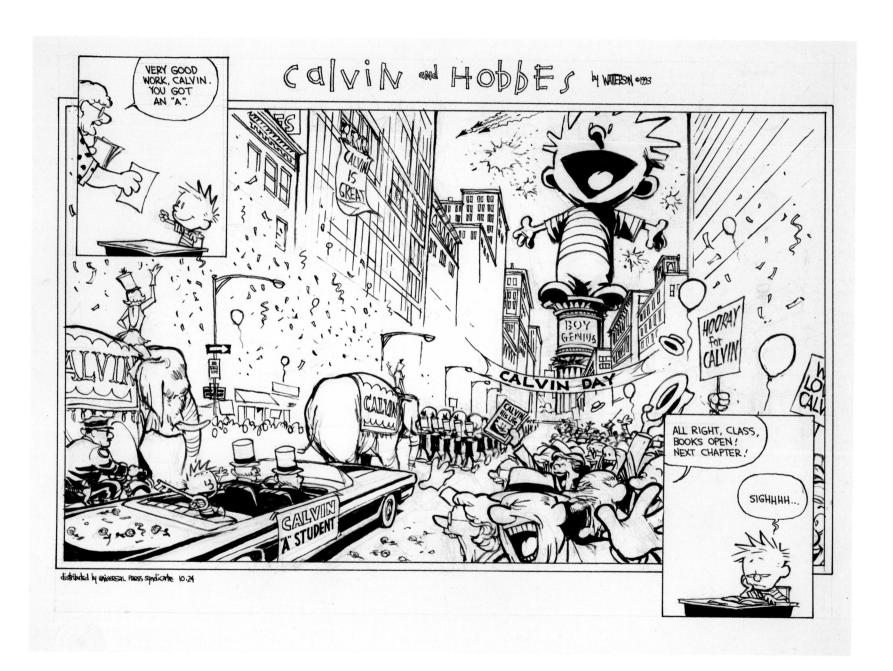

October 24, 1993

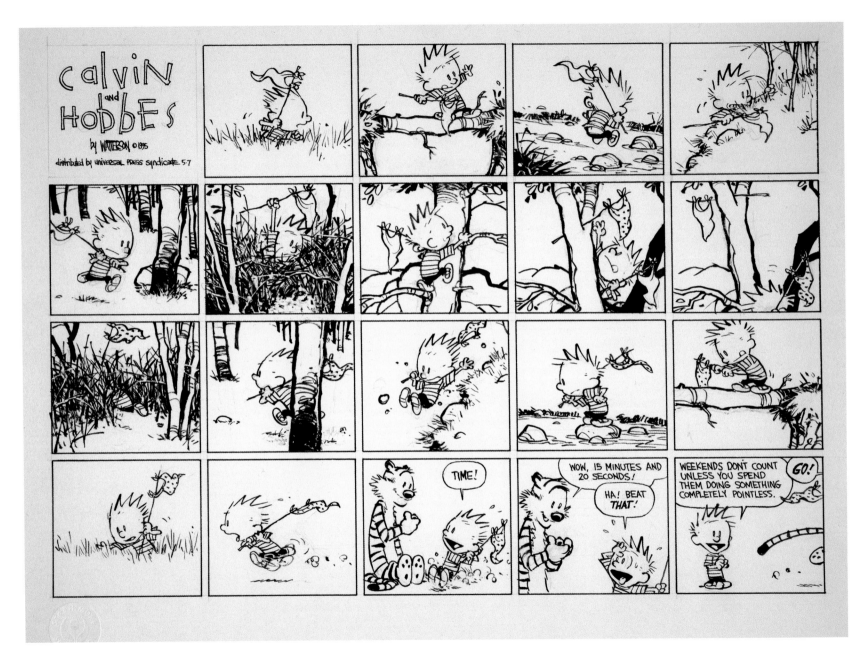

May 7, 1995

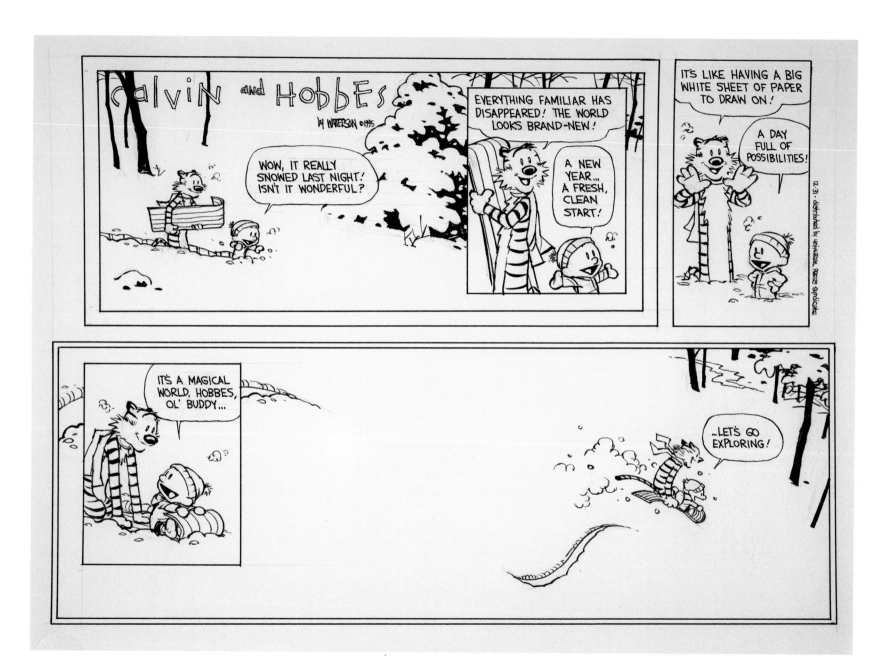

December 31, 1995

ACKNOWLEDGMENTS

KRAZY KAT © 1942 Distributed by King Features Syndicate, World Rights Reserved.

FLASH GORDON © 1936 Distributed by King Features Syndicate, World Rights Reserved.

PEANUTS © 1970 Peanuts Worldwide LLC. Dist. By UNIVERSAL UCLICK. Reprinted with permission. All rights reserved.

POGO © 1964 Okefenokee Glee & Perloo, Inc. Used by permission.

DOONESBURY © 1970 G. B. Trudeau. Reprinted with permission of UNIVERSAL UCLICK. All rights reserved.

BLOOM COUNTY © 1982. Reprinted with permission of Berkeley Breathed. All rights reserved.

OLIPHANT © 1974 UNIVERSAL UCLICK. Reprinted with permission. All rights reserved.

Where's Dessert? © 1989, Jim Borgman, *Cincinnati Enquirer*. Reprinted with permission of Jim Borgman. All rights reserved.

RALPH STEADMAN Self-caricature © 1989 Ralph Steadman. Reprinted with permission. All rights reserved.

EXPLORING CALVIN AND HOBBES

Andrews McMeel Publishing, LLC
an Andrews McMeel Universal company
1130 Walnut Street, Kansas City, Missouri 64106

www.andrewsmcmeel.com

15 16 17 18 19 SBD 10 9 8 7 6 5 4

ISBN: 978-1-4494-6036-5

Library of Congress Control Number: 2014946543

ATTENTION: SCHOOLS AND BUSINESSES
Andrews McMeel books are available at quantity discounts with bulk purchase for educational, business, or sales promotional use. For information, please e-mail the Andrews McMeel Publishing Special Sales Department: specialsales@amuniversal.

This catalogue accompanies the exhibition *Exploring Calvin and Hobbes* at the Billy Ireland Cartoon Library & Museum from March 22, 2014 to August 3, 2014.